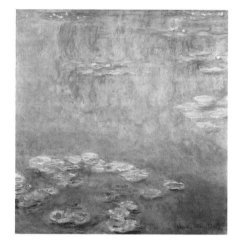

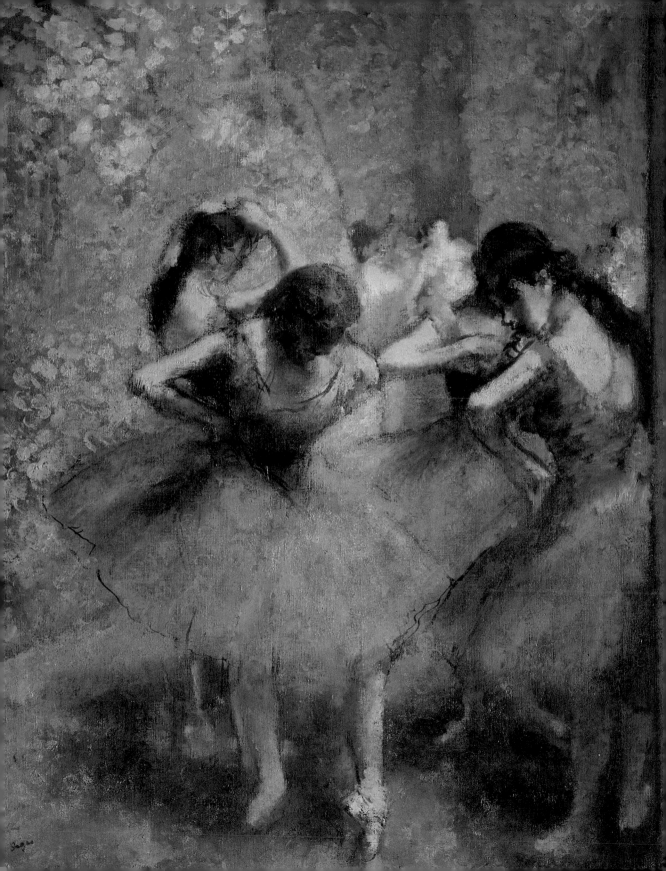

impressionism

KARIN H. GRIMME
NORBERT WOLF (ED.)

TASCHEN

HONG KONG KÖLN LONDON LOS ANGELES MADRID PARIS TOKYO

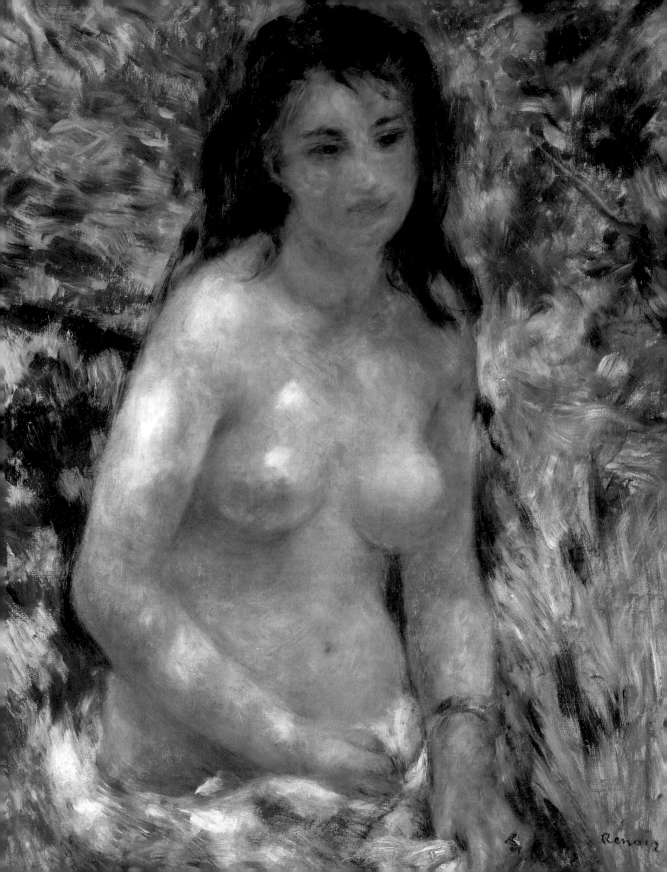

contents

Pictures created from Light and colour

on the banks of the seine

Shortly before his death in 1927, Claude Monet, one of the best-known Impressionist painters, wrote in a letter: "I always hated theories … My only merit is to have painted directly from nature and to have tried to reproduce my impressions of the most fleeting moods; I am deeply depressed to have been the cause of a name that was applied to a group, most of whose members were not Impressionists." And indeed, there is no general theory of Impressionism and no general agreement as to who was, or was not, an Impressionist. Pierre-Auguste Renoir, too, said of his art: "I have neither rules nor methods. Anyone can come and look at what I use, or watch me painting – they'll see that I have no secrets." (ill. p. 8 and p. 9)

The demarcation of Impressionism from other currents in art is no more clear-cut than the waters of the Seine which reflect the light in all directions. This is a motif that the French Impressionist painters at the end of the 19th century depicted time and again. And just as the light is reflected by the surface of the water, no less strong was the effect on their environment of a small group of painters who jointly exhibited their works between 1874 and 1886. They influenced not only other artists worldwide, but showed the bourgeois society of their age

a new, modern way of painting and of seeing. In so doing, they excited so much uproar that they were regarded as revolutionaries, and were largely excluded from the traditional art community of the academies. The Impressionist artists formed an opposition to this conservative art world.

The term "Impressionism" was applied to a whole current of art that started in France in the 1860s, although, as Monet said, most of the painters thus labelled were not Impressionists. Monet regretted the fact that it was the title of his picture *Impression – Sunrise,* shown at their first joint exhibition in 1874, that provided the label in the first place. Apropos this title: the French art critic Louis Leroy wrote very disparagingly of an "exhibition by the Impressionists." "Oh, it was a strenuous day when, in the company of the landscape painter Joseph Vincent, a … recipient of medals and awards from various governments, I ventured into the first exhibition on the Boulevard des Capucines … He thought he would find, as one does everywhere, good and bad painting – more bad than good – but not crimes of this nature … against the great masters and against form." The exhibition-going public were incidentally no less dismissive than some of the critics. The artists who had taken part in the exhibition soon adopted the negatively intended description for themselves, for the "impression"

1850 — Death of Honoré de Balzac, the great French novelist **1851 — Opening of the Great Exhibition, the first world fair, in London**

1852 — Napoleon III ascends the throne; start of the Second Empire in France

"Monet was just an eye, but what an eye."

Paul Cézanne

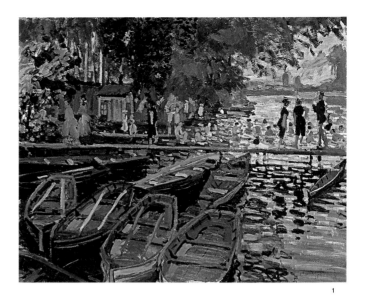

1. CLAUDE MONET
<u>La Grenouillère</u>
1869, oil on canvas, 73 x 92 cm
London, The National Gallery

1

was a central aspect of their art, and not just the title of one of the pictures on display at this first exhibition.

"Perfection rests on what they share in common"

… thus the painter Eugène Boudin on the Impressionists as a group. He even thought: "Without the others, none would have achieved the perfection which they did achieve." The individual artists would not have been in any position to resist the power of the Academy, nor their massive rejection by art-collectors, art-dealers and the public at large. But their solidarity and consistency gave them the strength to survive and eventually overcome the lack of interest shown by the art market. The special thing about the Impressionist movement is that the artists who comprised the group were bound by ties of friendship. Claude Monet, Pierre-Auguste Renoir, Edgar Degas, Alfred Sisley and Camille Pissarro worked and lived together, they suffered jointly during the years that their art was ignored, and joined forces to organize their own exhibitions and thus combat their constant exclusion from the annual exhibitions held by the French Academy of Art. For they were profoundly convinced that their pictures were worth exhibiting.

In 1867 Frédéric Bazille reported to his parents of his friends' plan to organize a special exhibition: "I'm sending nothing to the hanging committee any more. It is just too ridiculous … to be exposed to their moods … Besides me, a dozen talented young people are of this opinion. We have therefore decided to hire a large studio every year in which we can exhibit as many works as we want." They were unable to implement the exhibition plan, as they could not get enough money together. Years later, they had another try. At the end of December 1873, Monet, Renoir, Sisley, Degas, Morisot, Pissarro, Beliard, Lepic, Levert, Rouart and Guillaumin formed the "Société anonyme des artistes, peintres, sculpteures, graveures etc."

This company provided the organizational framework for the eight exhibitions which were held between 1874 and 1886. It was laid down that each of the artists should share in the costs, and that ten percent of the proceeds of any sale would be paid into the joint kitty. The hanging of the pictures was to be decided by lot in order to avoid any dispute. The photographer Nadar placed his studio, which he had cleared out because he was about to move, at their disposal free of charge. The rooms were on the second floor of a building on the Boulevard des Capucines. These Impressionist Exhibitions, as they are known today, did however include the work of many non-Impressionist painters.

1853 — Start of the Crimean War (Russia against Turkey, Britain and France) 1857 — Flaubert writes *Madame Bovary*
1859 — Start of the Italian War of Liberation 1861 — Outbreak of the American Civil War

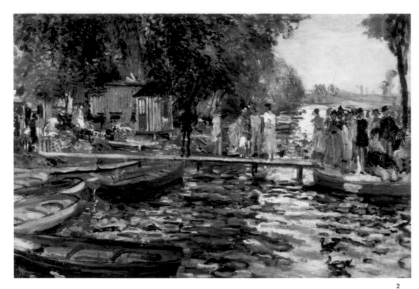

2. PIERRE-AUGUSTE RENOIR

La Grenouillère
1869, oil on canvas, 65 x 92 cm
Winterthur, Sammlung Oskar Reinhart
"Am Römerholz"

3. PIERRE-AUGUSTE RENOIR

Monet Painting in his Garden at Argenteuil
1873, oil on canvas, 50 x 107 cm
Hartford, Connecticut, Wadsworth Atheneum
Museum of Art, bequest of Anne Parrisch Titzelt

4. PIERRE-AUGUSTE RENOIR

Claude Monet with Palette
1875, oil on canvas, 85 x 60.5 cm
Paris, Musée d'Orsay

2

On 15 April 1874 they were ready to open their doors to the public with 165 paintings on display. Edmond Renoir, Pierre-Auguste's brother, compiled the catalogue. The exhibition ran for four weeks, and was not exactly overrun with visitors: a total of some 3,500 came to see the unusual works of the young artists. This was an insignificant number compared with the official Salon, which was visited by some 400,000 people. By 1886, a total of 55 artists had taken part in the Impressionists' exhibitions. Thirty were involved in the first show in 1874, but already by the time the second was held in 1876, this number had approximately halved. The founding members of the company had, to start with, successfully persuaded other painters of the advantages of a self-organized exhibition. Later, the friends concentrated on a smaller number of artists.

For all the differences between the individual members of the group, and in spite of the fact that it dissolved in the late 1880s, the Impressionists remained in close touch. In 1899, Monet hurried to see the dying Sisley, in order to perform a final duty of friendship. In the years following 1893, Renoir, as the executor of Caillebotte's will, attempted to ensure that matters were arranged as his friend had wished. But he failed in the attempt to present Caillebotte's entire art collection as a gift to the French state, and thus to get the many

Impressionist paintings into a museum. The cultural officials and responsible politicians were unable to imagine these pictures, which most of them did not recognize as serious art, in any museum. Gauguin had said, and it was meant critically, that the Impressionists were "tomorrow's official painters," but this tomorrow still seemed a very long way off. Gauguin himself had turned away from Impressionism in 1895, but stood by his Impressionist roots: "He [Pissarro] has borrowed something from everyone, it is said! Why not? Everyone else has borrowed from him ... He was one of my masters, and I do not deny him."

Camille Pissarro was also known by other artists and critics as the "father of Impressionism." Pissarro's works showed the way for the modern art of the 20th century. He influenced Gauguin and Cézanne no less than they influenced him. Many of the Impressionist pictures reflect the joint work of different artists. We can see this in Monet's and Renoir's pictures of La Grenouillère (ill. p. 7 and p. 8), a bathing lido with restaurant near Chatou, to the west of Paris. The two painters not only chose the same motif, but also a very similar way of painting. Likewise when looking at Cézanne's painting *The House of the Hanged Man* (ill. p. 10) and Pissarro's work *Hillside of the Hermitage* (ill. p. 11) we cannot help noticing how similar their approaches are. In

1863 — Founding of the Red Cross
1866 — Austro-Prussian War

1864 — Founding of the "First International" in London by Karl Marx
1867 — Death of the French poet Charles Baudelaire

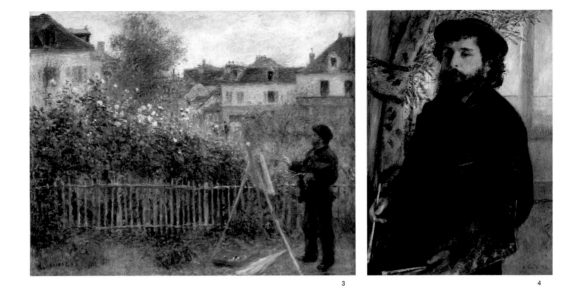

3 4

fact with numerous Impressionist pictures, the amazing similarity of painting style, technique and choice of motif is striking. Pissarro himself thought that it was wrong to think that "artists were the sole inventors of their style and they lacked originality when they resembled others."

Impressionism is, to stress the point once more, also the history of a friendship. Some of the friends are famous still, others are well-nigh forgotten. Too little attention has been devoted to artists such as Gustave Caillebotte, Frédéric Bazille, Félix Bracquemond and Armand Guillaumin in the historiography of art hitherto. The same is true of marginalized women artists such as Berthe Morisot, Mary Cassatt, Marie Bracquemond and the Pole Olga Boznańska (ill. p. 22). Many of these names are no longer even names to a broader public, astonishing in view of the popularity enjoyed by the Impressionists today!

modern moments

There is neither a set of rules nor a particular aesthetic programme by which Impressionism can be defined, and this makes the question of what Impressionism actually is all the more exciting. In-

stead of a precise characterization, which, if we are to believe Monet and Renoir, was not present in the 19th century either, all we can do is name a few criteria of varying importance which distinguish an Impressionist painting.

The Impressionist vocabulary includes without a doubt the direct, living "impression" of a moment, which is often reproduced in what seems a chance detail of the total event. These are scenes and figures of modern everyday life as opposed to the depictions from Classical or mythological stories, such as formed the stock-in-trade of traditional art until the end of the 19th century. Workers and prostitutes, passers-by in the street or guests in the café – the Impressionists were the first to regard such people as artworthy. "I have chosen something from our present age, because I understand it best and it seems to me to be the most alive for the living," wrote Frédéric Bazille.

The locations of modern life were depicted in ways as modern as they were unusual: railways and bridges, streets and parks, stations and cathedrals, opera-house foyers and cafés, the pleasures of bathing, beach-life, regattas and horse-races (ill. p. 21). Life in the city of Paris, the anonymous, big-city passers-by and their leisure and pleasure became the focus of attention. The innovation of the Impres-

1867 — Exposition Universelle in Paris
1870 — Start of the Franco-Prussian War
1869 — Tolstoy completes the novel *War and Peace*
1873 — Jules Verne writes *Around the World in 80 Days*

9

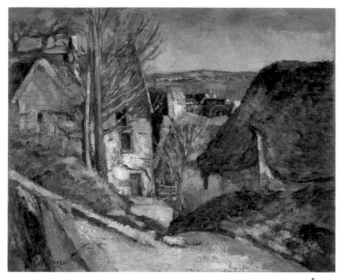

5. PAUL CÉZANNE
The House of the Hanged Man, Auvers-sur-Oise
1873, oil on canvas, 55 x 66 cm
Paris, Musée d'Orsay

6. CAMILLE PISSARRO
Hillside of the Hermitage, Pontoise
1873, oil on canvas, 61 x 73 cm
Paris, Musée d'Orsay

7. PIERRE-AUGUSTE RENOIR
Frédéric Bazille at his Easel
1867, oil on canvas, 105 x 75 cm
Paris, Musée d'Orsay

5

sionists lay not just in their choice of motifs, for depictions of cathedrals or cafés were nothing new. What they added was a specific execution and goal: "The joint intentions of the group, which lend it collective strength in the midst of our disunited age, consist not in striving for a polished execution, but in being content with a particular general aspect. Once the impression has been captured, their activity seems to be at an end. If one wished to characterize their intentions in a single word, one would have to create the new term Impressionist. They are Impressionists in the sense that they do not reproduce a landscape, but the impression that it invokes." (Castagnary)

In contravention of the existing rules of traditional painting, the works of the Impressionists seemed sketchy, spontaneous and "unfinished", as though they had been done in a few minutes and had not progressed beyond the preliminary stage. The rapid brush-strokes and the abandonment of painterly perfection are deliberate metaphors of the fleeting moment and the speed of everyday life.

Speed and dynamism were positively identical with modernity for 19th-century man. Movement was staged and celebrated via the depiction of ships and railways, horses and dancing-girls. In addition, the movement of the brush in the hand of the painter remains visible as a brush-stroke or spot of paint – spontaneity becomes the hallmark

of the painting process. Impressionism unites dynamic movement in the motif and in the execution.

Compared with Jean-Auguste-Dominique Ingres (1780–1867), the chief exponent of 19th-century French Neo-classicism, who took years to perfect a painting and conjured up on his pictures an enamel-smooth surface without a single visible brush-stroke, the young artists could indeed be thought of as quick workers. They were not concerned with naturalistic or idealizing depiction, as Ingres had still endeavoured to achieve, but with a spontaneous, present sensation. The Impressionists sought to reproduce as direct as possible an impression that emanated from the subject. By placing such an "impression" at the focus of their art as a subjective sensation, they emphasized the aspect of individuality, which is quite generally a characteristic of modern societies. Impressionist art thus reflects the process of social change.

Inseparable from the creative concerns of Impressionism is its treatment of colour and light. The fact that shapes, contours and lines played a relatively subordinate role was one of the innovations which many of those who viewed these pictures at the time found incomprehensible, indeed ridiculous. Ingres had given the 20-year-old Edgar Degas, who admired the old classicist, this piece of advice: "Draw lines,

1874 — Johann Strauss the Younger composes the operetta *Die Fledermaus*
1874 — First group exhibition by the French Impressionists

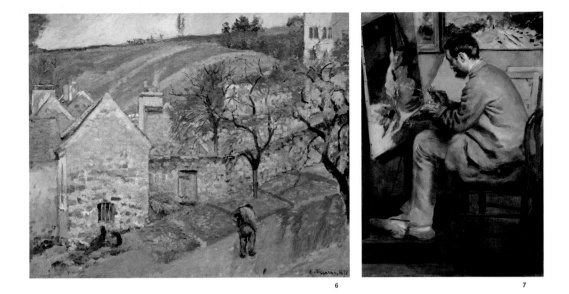

6 7

young man, many lines, from memory and from nature. Then you'll be a good artist." Unlike his friends, Degas remained largely faithful to this counsel.

For most Impressionist painters, by contrast, colour and light were the preferred means of capturing the brief moment, the speed of passing time. In addition, the desired subjective impression can be reproduced with colour and light far more exactly than with exact contours or internal lines. Frédéric Bazille explained this in a letter to his parents in 1866: "I think, by the way, that if my work is interesting as painting, the motif is not very important."

The motif, whether an isolated object or a scene, receded into the background vis-à-vis the colour, light and painterly execution. For Bazille and Monet, colour and light were more important than the motif itself. What comes across as "normal" for today's beholder – corresponding as it does to today's visual habits – was in the 19th century tantamount to an unheard-of sensation, a revolution in seeing. If Pierre-Auguste Renoir depicted his *Female Nude in the Sunlight* (c. 1875/76, Paris, Musée d'Orsay; ill. p. 4) with green, blue, red and white patches on her skin, it was to visualize the play of light and the reflections of the colours that characterized the surroundings. "I look at a naked body and see innumerable tiny colour shades. I have to find those that bring the flesh to life and vibrancy on my canvas." Just how unfamiliar and disturbing this manner of seeing was is made clear by the reaction of the art-critic Albert Wolff, who, in an article for *Le Figaro* on the second Impressionist exhibition in 1876, interpreted the colourful sun-spots on the skin as "rotten meat."

The great importance of coloration in Impressionist art went hand-in-hand with a growing colourfulness in the world outside of art. From the beginning of the 19th century, various chemical and technical advances had led to an enormous growth in the availability of dye-stuffs. The market had been flooded with synthetic dyes like mauve (since 1856) and alizarin red (since 1868) which were more permanent than natural dyes. Textiles and clothing became more colourful, and, thanks to mass-production, they also became cheaper and consequently more affordable to a broad public. One visitor to the first Impressionist exhibition in 1874 expressed the view, more or less jokingly, that the artists must have loaded a pistol with a number of tubes of paint and fired them at the canvas, leaving only the signature to be added. There was indeed a serious core at the heart of this remark: namely the visual strain on the public caused by the intensity of the colours and the free coloration, which depended not on the object, but on the light.

1875 — George Bizet's opera *Carmen* fails at its premiere in Paris 1876 — Opening of the Festspielhaus in Bayreuth
1876 — Schliemann starts his excavations in Mycenae

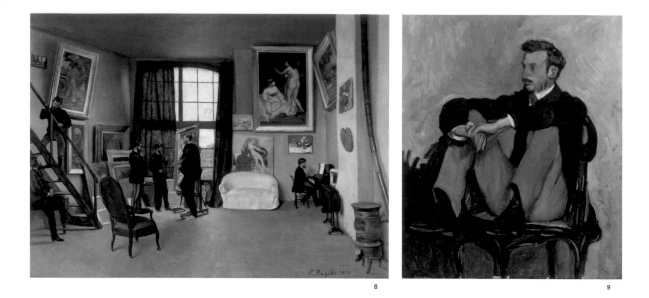

8

9

Already since the late 1860s, Monet had been using the new green known as viridian, which had been available since 1862. Unlike the traditional "vert émeraude," this chromium oxide was non-toxic and did not trigger chemical reactions when it came into contact with other pigments. The purple, too, a cobalt phosphate which Monet used for the mauve flowers in his painting *La Grenouillère* (ill. p. 7), had only just appeared on the market. The Impressionists very much preferred working in the open air, and a further development in paint technology also encouraged this: in 1841, paints were supplied for the first time in metal tubes with replaceable caps. The laborious fiddling around with powdery pigments that could be blown away by every breath of wind was no longer necessary, nor did the pigment any longer have to be stirred. This does not mean, however, that the Impressionists from then on abandoned the use of traditional pigment paints.

Until well into the 19th century, there had been a maxim that "the painter should never attempt to paint a landscape in the midday sun, as pigments were unable to do justice to this particular light effect, and the sun itself should never be depicted directly" (John Gage, Colour and Culture, 1993). Now the young Impressionists took up this gauntlet. For the searing light of the midday sun on the Pont Neuf Renoir chose white, grey and yellow shades, in which individual dabs of red stand out in the clothing and on the flag. The pavement, the roadway, the houses, the people, the horses, the carriage on the bridge, everything is bathed in the same glaring noonday brightness.

The availability of paints and appropriate pigments in the second half of the 19th century created the material basis and an important precondition for Impressionist art. In addition, there was the wealth of ideas and the courage of the young generation to use the new opportunities, even if, as a result, it meant contravening the precepts of the old masters.

Apart from the similar motifs and comparable painting technique, the French Impressionists also shared the same paint dealer, namely Julien Tanguy, known as Père Tanguy, who started off as an itinerant trader before opening a shop in Paris in 1871. Tanguy supported the young artists, who were always in financial difficulty, by accepting their pictures, which most contemporaries regarded as worthless, in exchange for paint and canvases. In this way he was not just a supplier of paints, but also an art collector. Without his support, many a picture could never have been painted. One has only to think how Renoir gathered the paint tubes thrown away by other students, and how Monet and Pissarro scraped off the paint from finished pictures in order to use the canvas a second time.

1877 — Tolstoy completes *Anna Karenina* **1878 — Exposition Universelle in Paris**

 1880 — Rodin models the bronze *The Thinker* **1881 — Birth of Pablo Picasso**

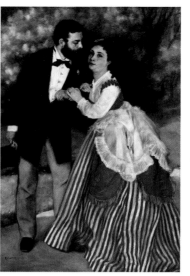

10

"The painter, the true painter, will be the one who knows how to see the epic side of our present-day life, who, by painting or drawing, lets us see and understand how great we are, and how poetic in our cravats and polished boots."

Charles Baudelaire

continuity and innovation

From today's point of view, Impressionism certainly did not just arise from nowhere. On the contrary, it was part of a continuous development from Realism, Naturalism and Neo-classicism. Alongside the various currents in French art, another major influence was Japanese woodcuts, which were on show in Europe for the first time.

Otherwise, the exponents of Realism, Théodore Rousseau, Camille Corot, Johan Barthold Jongkind, Charles-François Daubigny, to name but a selection, had already helped the landscape genre, which hitherto had not counted for very much, to obtain its just deserts. In the relevant works by these artists, we already see the reflecting light which was to play such an important role in Impressionist art. In the mid 19th century, some of the Realist painters had left the hustle and bustle of the city to withdraw to the countryside. They lived and worked in Barbizon in the forest of Fontainebleau, which is why they are known as the "Barbizon School."

The Barbizon artists worked in the open air, or as the French say "en plein air." The painting of landscapes as realistically as possible "liberated" them from more complicated contents. The landscape was staged purely for painterly effects. This meant a positively absolute freedom from the existing rules and constraints of art as traditionally taught in the academies. These artists made a thoroughgoing break with what till then had been the usual studio painting. The effect of light, in the view of the Barbizon school, should be reproduced as realistically as possible. In order to guarantee the authenticity of the painted landscape, it was essential to set up one's easel in the open air. The atmosphere and the colours resulting from this atmosphere were no longer used merely as a means to cast the scenery "in the right light," rather, the light effects took on a certain life of their own, which pointed the way to Impressionism.

Corot's painting *Daubigny at Work on his Boat near Auvers-sur-Oise* depicts, with the boat, a motif which the Impressionists were later often to choose. Corot allows the reflected light to float on the water and sketches the trees in the foreground with rapid brushstrokes. The "master of light", as he was known, was doubtless one of the pioneers of Impressionism. Corot's painting shows a fellow-artist working on the water, Claude Monet, and the Post-impressionist Paul Signac, were later also to paint in boats. Édouard Manet, who can only be assigned to the Impressionist circle for a short time, watched Monet doing so. *Monet Painting on his Studio Boat* (ill. p. 14) is one of Manet's most strongly "Impressionist" paintings. Manet asserted

1881 — Jacques Offenbach composes the opera *Tales of Hoffmann* 1881 — Louis Pasteur introduces the rabies vaccine
1882 — Robert Koch discovers the tuberculosis bacillus

13

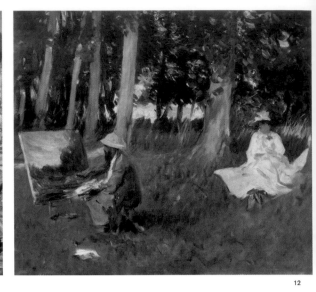

11

12

that "the light appeared to him in such unity that a single shade of colour was enough to depict it, and it was better, even if it might come across as coarse, to move abruptly from light to shade than to pile up things that the eye does not see and that not only dulls the power of the eye but also weakens the colouring of the shadows – which are precisely what ought to be emphasized." It was precisely in discussions about light and shade that Manet, who stressed the contrast, set himself off clearly from the Impressionists.

Another role-model in respect of light and shade was Johan Barthold Jongkind. He was already, in the early 1860s, painting views of Notre-Dame Cathedral in Paris in different lighting conditions. One of his earliest examples in this area is *Notre-Dame in Paris by Moonlight.* The church at night or on a cold, clear winter's day appeared quite differently to its appearance in the atmosphere of a warm sunset. "With him [Jongkind] everything lies in the impression," it was said, before the Impressionist movement had even begun.

Jongkind's initiative was taken up by John Singer Sargent and above all Claude Monet with his sequences of pictures, including those of *Rouen Cathedral,* which were painted thirty years later. The development can be traced from Jongkind's Notre-Dame paintings via Monet's Rouen Cathedral pictures right up to Kandinsky's

Ludwigskirche in Munich (ill. p. 51). A comparison shows how much more strongly Monet allows individual forms and details of the building to blur in the light, and how the colours alone determine the impression. This tendency in 19th-century art presupposes that the very personal, subjective impression of an individual is not only worth depicting, but is recognized as the measure of life in society. And so the foundation was laid for the triumphal march of the individual in the modern world.

A picture is determined by individual feeling: that was the demand of Gustave Courbet, who was a decisive influence on Realist painting. Only one's own reality, which also encompasses social and political relationships, can, in his opinion, be the starting point for art and its – ultimately political – function.

Courbet's work thus focused on figural depictions such as the *Young Girls on the Banks of the Seine (Summer)* (ill. p. 18). The public of the time would have presumed the girls to be prostitutes. In particular the half-closed eyes of the young woman resting in the foreground, her hands and feet relaxed as she drowses, and the semi-clothed body, allowing more than a glimpse of the sensual shimmer of sweat on her skin, were not perceived in terms of a harmless lunchtime nap beneath the summer sun, but as vulgar and unseemly.

1883 — Friedrich Nietzsche starts *Thus Spake Zarathustra* and coins the term "Übermenschen" (Overmen, Supermen)
1883 — Explosion of the volcanic island Krakatoa

11. ÉDOUARD MANET

Monet Painting on his Studio Boat
1874, oil on canvas, 82.5 x 100.5 cm
Munich, Neue Pinakothek

12. JOHN SINGER SARGENT

Claude Monet Painting by the Edge
of a Wood
1885, oil on canvas, 54 x 64.8 cm
London, The Tate Gallery

**13. CHARLES-FRANÇOIS
DAUBIGNY**

The Haystack
c. 1856, oil on wood, 14.4 x 25.3 cm
Pontoise, Collection Musées de
Pontoise, Musée Tavet

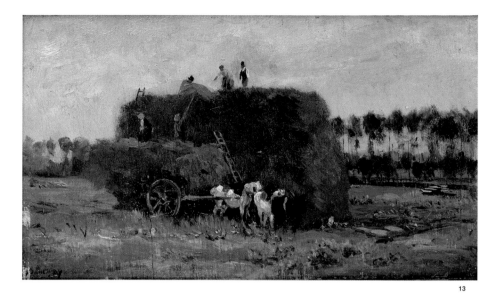

13

Courbet chose to depict the girls not while they were working, but during their lunch-break, so to speak. It was also their obvious exhaustion that animated Edgar Degas, among others, to depict his tired and enervated ballerinas backstage or after a rehearsal (ill. p. 43). Courbet captures the recumbent girl not from above, but from an angle that puts beholders on the same level, as though they too were lying on the grass. Painter and models, in the work of Courbet and Degas, come across as being on one level, with none of the moral aloofness of bourgeois society. The patches of light, depicted with white paint, and the generally relaxed, lively brush-strokes point the way to the Impressionists, above all to Monet and Renoir. Courbet's work already represented a radical break with the visual habits of the age, ushering in the transformation that was continued by the Impressionists. It became a favourite pastime for city-dwellers on a scorching summer's day to escape the heat of the city and ride on the new railway into the surrounding countryside. The destinations of these excursionists along the banks of the Seine thus in particular provided the Impressionists with many of their motifs.

Among the landscape painters it was Charles Daubigny especially who broke the ground for the Impressionists; Monet in particular was strongly influenced by him. Motifs like haystacks (ill. p. 15 and p. 17) and rows of poplars had been appearing on the canvases of the new style with some regularity since Jean-François Millet and Daubigny. The latter's pictures were already painted exclusively in the open air. He loved riverside views in the changing light; he juxtaposed patches of paint to make it appear improvised and fleeting. This sketchiness underlined the spontaneous and authentic process of painting, and evoked vehement protests from public and critics alike. It was regretted that he should content himself with a mere "impression" instead of producing a "proper" painting, that is to say a finished, smooth-surfaced picture with no visible brush-strokes. Daubigny was even accused by art-critics of being the "ringleader of the Impression school."

Realist art therefore had a strong influence on Impressionism, while Neo-classicism à la Ingres also left traces, albeit few, in Impressionist paintings. In particular Edgar Degas and Marie Bracquemond admired Ingres. The importance for Degas, following Ingres' example, of lines and drawings, was reported by Walter Richard Sickert, writing about Degas in 1917: "'I always sought', he [Degas] said 'to persuade my fellow-artists to look for new combinations by way of draughtsmanship, which, as I think, is a more fertile field than colour. But they would not listen, and took the other path.'"

1885 — The American painter James McNeill Whistler emphasizes the importance of Japanese art
1886 — Rodin completes his famous sculpture *The Kiss*

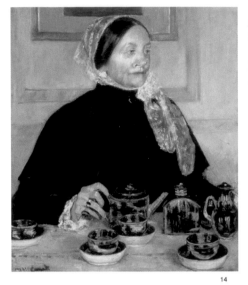

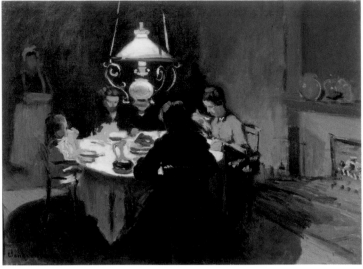

14

15

Unlike other Impressionists, who placed their work almost exclusively in the service of colour, Degas never neglected the aspect of draughtsmanship. As early as 1859, he described the spectrum of his motifs in a notebook: "… to depict all kinds of utilitarian objects in such a way that one can still see what they were used for, in such a way that one can feel in them the life of the man or woman – a corset for example, that has just been taken off, and still bears the shape of the body … Monuments and houses have never been depicted from close up, as one sees them when walking along the street …" His list of the contemporary things that he wanted to study and paint continued: "Musicians with their various instruments, bakeries from various angles … smoke: cigarette smoke, smoke from railway engines, chimneys, steamers etc … Dancing-girls of whom one sees nothing but the naked legs, observed in full movement, or having their hair done; countless impressions such as all-night cafés with the various graduated shades of light reflections in the mirrors etc."

Degas' predilection for unusual angles, such as had not been shown in art previously, had crystallized at an early stage. His openness towards unusual composition patterns is also revealed in the experimental way in which he handled new techniques such as photography and various print technologies.

The young Marie Bracquemond was encouraged by Ingres in the 1860s, and worked in his studio. The art-critic Philippe Burty, a close friend of her husband Félix Bracquemond, called her "one of the most intelligent pupils in Ingres' studio." Probably on account of their shared admiration for Ingres, she was closely more befriended with Degas than with the other painters. The extent to which Marie Bracquemond succeeded in integrating Impressionism with the traditions handed down by Ingres can be seen in exemplary fashion in her painting *Afternoon Tea* (ill. p. 31).

In addition, Ingres, Courbet and, yes, the Impressionists too had in common that they were at first totally rejected by the art world, and had to look out for their own opportunities of displaying their work to a broader public. Ingres only presented his pictures occasionally at small studio exhibitions, even at a time when as a famous painter with an acknowledged reputation, he no longer had to fear the onslaught of the art-critics, who had made life very hard for him to start with. In 1855, Courbet, whose pictures had been regularly rejected, decided to hold his own exhibition and even had a pavilion erected at his own expense in which to display his works. Rejection by the Academy exhibition hanging committee was, then, nothing new, and affected others besides the Impressionists.

1888 — In Belgium James Ensor paints his well-known work *Entry of Christ into Brussels*
 1888 — Founding of the Pasteur Institute in Paris 1889 — Birth of Charlie Chaplin

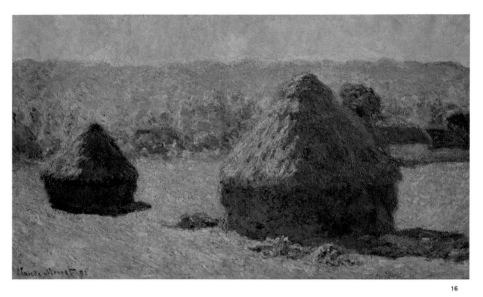

14. MARY CASSATT
Lady at the Tea Table
1883–85, oil on canvas, 73.7 x 61 cm
New York, Metropolitan Museum of Art

15. CLAUDE MONET
Dinner at the Sisleys
1868/69 or 1872, oil on canvas,
51 x 66 cm
Zurich, Foundation E. G. Bührle
Collection

16. CLAUDE MONET
Haystack, Late Summer, Morning
1891, oil on canvas, 60 x 100 cm
Paris, Musée d'Orsay

16

While Bracquemond underwent a traditional apprenticeship with Ingres, Claude Monet, Pierre-Auguste Renoir, Frédéric Bazille and Alfred Sisley got to know each other in Gleyre's studio in 1862. Marc-Charles Gleyre (1806–1874), like other professors at the Academy, offered private courses alongside the classes which students were obliged to attend. He charged nothing except for each student's share of the model's fee and the cost of hiring the room, and consequently his lessons were always well attended. He taught traditional painting techniques, and was none too happy about Renoir's enthusiastic use of colour. But usually he allowed the students to do what they wanted, said Renoir later, and only occasionally corrected them.

The impressionists

The appearance of an artistic current like that which is to be found in Impressionism was only possible because there were open-minded young artists looking out for ways of doing something new. This precondition was present only in France. So who were these young men and women who were to form the core of the Impressionist movement?

Unlike the others, Monet was no longer a beginner, but had already painted alongside Jongkind and other fellow-artists. To those young artists who were searching for new forms of expression, his acquaintanceships and wide contacts put across the new ideas of the Realists: open-air painting and the endeavour to depict, in as immediate a fashion as possible, what was there in nature before their eyes.

Monet met Camille Pissarro at the Académie Suisse. In the late 1850s, this academy was a well-known institution in Parisian art circles. It was run by Père Suisse, who had long worked as a model in the studios and now gave artists the opportunity, in a large well-lit room, to paint from life without a teacher, without compulsory attendance, and without instructions.

Here, Monet stood out from the crowd by dint of his unusual talent; he could draw rapidly and accurately, and capture the essentials. Pissarro was technically less mature, even though he was ten years older than Monet and probably no less ambitious. Pissarro and Monet were bound by the common ideal of open-air painting, and they wanted above all to paint landscapes. They wanted to artistically capture all that they saw, irrespective of whether or not it matched society's norms of beauty. Their strong orientation to the Realist school encouraged them to implement nothing but their personal, subjective

--
1889 — The Austrian writer Baroness Bertha von Suttner publishes the pacifist novel *Lay Down Your Arms*
1889 — Erection of the Eiffel Tower for the Exposition Universelle in Paris
--

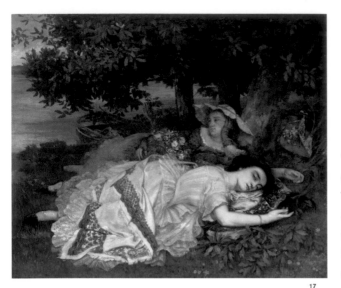

17

"Beauty is in nature, and we encounter it in reality in a great variety of forms. once we are aware of it, it belongs to art, or rather the artist who can recognize it."

Gustave Courbet

visual impressions. It was not for nothing that Corot said to Pissarro: "Since you are an artist, you need no advice other than this: you must study the colour values above all. We do not all see identically: you see green, and I see grey and 'blond'. But that is no reason for you not to work out the colour values, for they are the starting-point for everything, however one feels and wishes to express oneself, without them there is no good painting."

To reproduce the mutual relationships of the colour-values on a finely graduated scale from light to dark according to their own perception – that was the method used by most of the young painters in order thus gradually to distance themselves from Realism. It was no longer objective realism that was at the centre of their endeavour, but totally subjective perception.

Pissarro had probably already been in contact with Corot since the late 1850s, as he described himself in the following decade as the latter's pupil. In 1866 Pissarro was mentioned in the press for the first time. The not-yet-famous French writer Émile Zola (1840–1902), then an art critic, wrote with an ironic undertone: "M. Pissarro is an unknown, who will probably not be talked about … Many thanks, Monsieur, on my journey across the great desert of the Salon I was able to rest for half an hour in front of your landscape. I know that your

painting was accepted with some difficulty, my hearty congratulations Otherwise, be aware that no one likes your picture, they say it is too bald and too black. How the devil can you be so blatantly inept as to paint honestly and study nature so frankly? How can you just depict the winter, a simple stretch of road, a hillside in the background and open fields stretching to the horizon? Nothing for the eye to rest on An austere, serious style of painting, with an extreme care for truth, an acerbic, strong will. You are very maladroit, Monsieur – you are an artist that I like."

This notice brought Pissarro no customers, and by then was already married and the father of two children, he found himself in great financial distress. He knew from his own experience what social and economic inequality and injustice meant. It was for this reason that the social-critical works of the anarchist writer Pierre-Joseph Proudhon (1809–1865), in particular the passages on the social responsibility of art, aroused his political interest. It was due not least to reading Proudhon that he himself acknowledged his adherence to anarchism as a political creed. Pissarro wrote: "Proudhon says in his work *O Justice in the Revolution and the Church* that love of the earth is linked to the revolution, and consequently with the artistic ideal." The painter lived for most of the time in the countryside, which is where he

1890 — Vincent van Gogh commits suicide 1890 — Kaiser Wilhelm II dismisses Bismarck
1891 — Oscar Wilde writes the novel *The Picture of Dorian Gray*

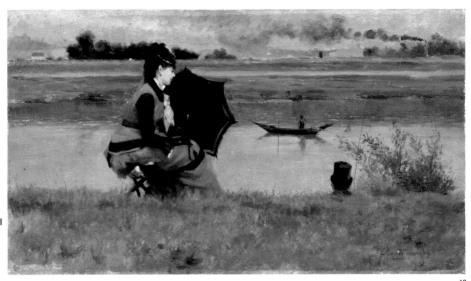

17. GUSTAVE COURBET
<u>Young Girls on the Banks
of the Seine (Summer)</u>
1856/57, oil on canvas,
174 x 206 cm
Paris, Musée du Petit Palais

18. FEDERICO ZANDOMENEGHI
<u>On the Banks of the Seine</u>
1878, oil on canvas, 15 x 25 cm
Florence, Galleria d'Arte Moderna di
Palazzo Pitti

18

found most of his motifs. Pissarro had a fellow-feeling for others that was no less strong than his feeling of solidarity with the group. He became one of the driving forces at the Impressionist exhibitions, and was the only painter to take part in all eight between 1874 and 1886.

Monet, although born in Paris, grew up in Le Havre on the Normandy coast. In his youth he like to draw caricatures, with which he earned a little money. The landscape artist and picture-frame maker Eugène Boudin (1824–1898) allowed him to display his pictures in his shop-window. In this way Monet was able to gain access to a public for the first time.

Boudin also put the young Monet in touch with Constant Troyon (1810–1865), in whose Paris studio he continued his artistic training in 1859. Troyon in turn introduced Monet to the Realist landscape painters, Corot and Daubigny. In 1862 Monet met the Dutch painter Jongkind in Le Havre. Monet himself said later: "From then on he [Jongkind] was my real master. I owe the definitive training of my eye to him."

As to the impulses he received from other artists, Monet wrote in a letter to his friend Frédéric Bazille as follows: "You may find a certain reference to Corot, but that has nothing to do with imitation; the motif, and above all the tranquil crepuscular atmosphere are alone

to blame for that. I worked on it as conscientiously as possible, without thinking of any particular painter."

Monet, Bazille and Renoir lived together for a time, they painted together and shared their idealistic faith in their modern art.

Renoir's father was a tailor and lived a lower-middle-class life with his family. The son, Pierre-Auguste, had consequently to learn a trade while still quite young, and as he displayed a talent for drawing, he became a porcelain painter. He often copied on to plates and cups the masterworks of French 18th-century art, of which he made an intense study, above all those of Antoine Watteau and François Boucher. Boucher's *Diana Leaving her Bath* (1742, Paris, Musée National du Louvre) was for Renoir the first picture "to seize me, and I have never ceased to like it." One of Renoir's early paintings, still in a very realistic style, also depicts a *Diana* (1867, Washington, National Gallery of Art). But then the hand-painting of porcelain was overtaken by technological developments and Renoir abandoned this job. He had saved some money in order to begin a course at the École des Beaux-Arts. The group of friends to which Renoir belonged was the one most strongly oriented towards traditional art. Unlike Pissarro, who absolutely refused to visit museums or to study the old masters, Renoir, Monet, Degas and Bazille were among the many copyists who

1891 — Gauguin emigrates to Tahiti 1891 — Otto von Lilienthal makes the first gliding flights
1892 — Henri van de Velde starts making craft designs (beginnings of Art Nouveau)

19

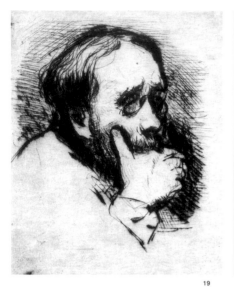

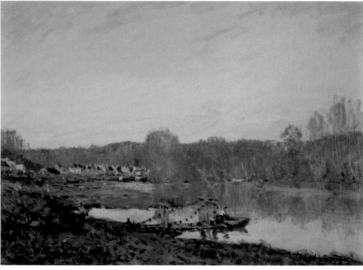

19

20

frequented the halls of the Louvre. To make copies, for them, meant to use the great paintings in the museums to hone one's own composition and coloration skills. This widespread practice was an important part of artistic training at the time.

The Louvre was of course also an appropriate place to meet like-minded artists. These included Berthe Morisot, who copied paintings in the Louvre together with her sister Edma (ill. p. 22). The hobby which she pursued as "a well-bred girl" had long since become her profession. That she was also the great-niece of the French Rococo painter Jean-Honoré Fragonard (1732–1806) doubtless encouraged her artistic inclinations. Camille Corot, whom she had met through her teacher in 1861, advised her to go and see Daubigny in Auvers-sur-Oise. In her landscapes and townscapes of the 1860s she did indeed orient herself towards the Barbizon school, as evidenced by *The Harbour at Lorient* (ill. p. 24). She sat a number of times to her close friend Édouard Manet, whose brother Eugène she married, and she also features, together with her daughter Julie, in several works painted by Renoir in the 1880s. In spite of the double burden of being a wife and mother, Berthe Morisot took part in all but one of the Impressionist exhibitions. With her more personal motifs, her pale colours and her daring brushwork, she brought a breath of fresh air into the

exhibition rooms. And unlike the other Impressionists, who later went their separate ways, Morisot remained an Impressionist always.

The painting *Harbour at Lorient* is testimony to her concern with questions of figure composition in landscape painting. In this example she placed her sister on the harbour wall. Berthe Morisot said of Frédéric Bazille that he had solved the problem of balance between figure and landscape. Bazille had, a number of times, applied the idea of placing a figure on a wall and thereby achieved an extremely lively and authentic impression.

Unlike Morisot and Bazille, Alfred Sisley attached more importance to the landscape itself. His landscape paintings are either devoid of people or, as in *Autumn: On the Banks of the Seine near Bougival* (ill. p. 20) little figures are present which are perceived more as parts of the surroundings than as beings in their own right. Sisley, born in Paris as the son of an English merchant family, had belonged since the 1860s to the inner circle of friends of Monet, Renoir and Bazille, with whom he often painted together. Renoir has left a loving memorial to him in his *Alfred Sisley and his Wife,* which depicts him together with his wife Marie née Lescouezec. Claude Monet also portrayed Sisley in his family circle, where he was a frequent guest. Monet's painting *Dinner at the Sisleys* (ill. p. 16) provides a very

1893 — Edvard Munch paints *The Scream* 1894 — Start of the Dreyfus affair in France
1894 — Rudyard Kipling writes *The Jungle Book*

"He is intolerable, but we must acknowledge that he has a great deal of talent."

Gustave Caillebotte on Degas

19. GIUSEPPE DE NITTIS

Portrait of Edgar Degas
c. 1874, etching, 8.6 x 7.1 cm
Paris, Cabinet des Estampes

20. ALFRED SISLEY

Autumn: On the Banks of the Seine near Bougival
1873, oil on canvas, 46.3 x 61.8 cm
Montreal, Musée des Beaux-Arts

21. EDGAR DEGAS

Jockeys Before the Race
1878/79, oil on paper, 104.3 x 73.7 cm
Birmingham, Barber Institute of Fine Arts,
The University of Birmingham

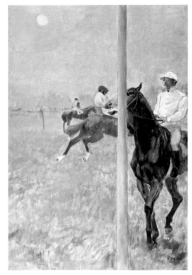

21

private glimpse by a friend into the warmth and intimacy of a family atmosphere.

Sisley's special artistic predilection was for depictions of water and land together, for example floods, harbours and rivers. In the 1870s he painted more than twenty views of the Seine near Bougival, and displayed his landscapes at a number of Impressionist exhibitions. The scene *Autumn: On the Banks of the Seine near Bougival* is a wonderful example of his typical luminescent coloration, which earned him the epithet of "poet of Impressionism." Sisley's landscape is the depiction of a crossing in a double sense: the passing from one season to the next, and the physical crossing of the river on the ferry.

The great importance of Impressionism for the future development of art was clearly recognized by Vincent van Gogh, who only came to Paris in 1886. "What the Impressionists achieved by way of colour will be further increased; but many forget that they are directly linked with the past …"

When van Gogh visited Paris and his brother Theo, he still had no proper idea of Impressionism and arrived just in time to see the eighth and last Impressionist exhibition, which opened on 15 May 1886. During the next two years in the French capital he was introduced by his art-dealer brother to Pissarro and Degas, whom he greatly admired.

For van Gogh, Impressionism was no more than a transitional phase in the search for a style of his own. It was in his relationship to reality that he himself saw one important difference between him and the Impressionists: "For instead of depicting exactly what I see in front of me, I use colour in a more individual way in order to express myself very intensely." In his use of colours, van Gogh came close in particular to Claude Monet, whom he profoundly admired. "Oh, to paint figures the way Claude Monet paints landscapes! That's something I still have to do, in spite of everything …"

The works which van Gogh painted in Paris, including the *Portrait of Père Tanguy* (ill. p. 45), show his approach to colour under the influence of Impressionism. Monet valued van Gogh's work, telling Theo that he considered his paintings the best in the Indépendants exhibition held in Paris in 1890. Camille Pissarro was the most open to van Gogh's influence, and introduced him to Dr Gachet in Auvers, who hoped to deal with his psychological problems. It was here that Vincent van Gogh took his own life in July 1890. Pissarro said of him, "[I said] this man would either go mad, or leave us all far behind. I had not reckoned on him doing both."

1894 — Debussy composes *L'Après-midi d'un Faune*, a tone-poem seen as the first work of musical Impressionism

1894 — First international motor-race Paris – Rouen 1895 — Röntgen discovers X-rays

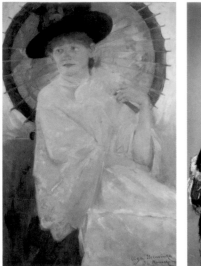

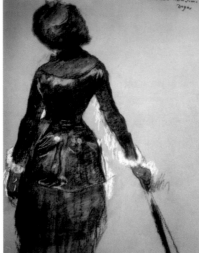

22 23

22. OLGA BOZNAŃSKA
Woman with Japanese Parasol
1892, oil on canvas
Private collection

23. EDGAR DEGAS
Study to Mary Cassatt in the Louvre
1879/80, pastel on paper,
64 x 48 cm
Philadelphia, McIlhenny Collection

24. EDGAR DEGAS
**The Ballet Scene from Meyerbeer's
Opera Robert le Diable**
1876, oil on canvas,
76.6 x 81.3 cm
London, Victoria and Albert Museum

тhe last joint exhibition

At the last Impressionist exhibition, the only one that van Gogh saw, few of the original artists were represented. Marie Bracquemond, Mary Cassatt and Berthe Morisot were there, as were Degas, Guillaumin, Pissarro and Federico Zandomeneghi (ill. p. 19 and p. 95).

Two new talents in particular, who further developed the Impressionist painting technique, turned up in the list of artists on display in 1886 for the first time: Georges Seurat and Paul Signac. Edgar Degas called the young Seurat "the notary" on account of his invariably correct attire, complete with top-hat, the way he always arrived home punctually for dinner with his family, and his world of ideas, which was systematic and scientific.

Seurat occupied himself intensively with optical phenomena and laws, and developed contemporary colour theories to the extent of creating the Pointillist technique. His starting point was the "colour circle" worked out by the chemist Michel Eugène Chevreul (1786–1889), who had influenced all the Impressionists.

Pointillist painting technique involved applying the paint to the canvas in little dots in such a way that a diaphanous, shimmering synthesis arises from the interplay of different colours. This so-called Divisionist style was the basis of the Post- or Neo-impressionist school, to which, alongside Seurat, Signac and for a time Camille Pissarro also belonged. Seurat set up a series of rules, the first of which was: "Art is harmony." The painting *Bathers at Asnières* was the first work in which he applied the scheme he had developed (ill. p. 79).

Giovanni Segantini, Italian by birth, also adopted Pointillism, combining it with a Realist view of nature. His very individual landscapes of the Swiss and Italian Alps, like the early Impressionist works, lay stress on colour and light. But the scenery for Segantini no longer stands just for itself, but is charged with symbolic meaning. His painting *The Hay Harvest* (ill. p. 77) takes up the "haystack" motif of the early Realists and Impressionists, but the meaning is different. Thus it was that his Symbolism grew out of Impressionist principles.

Ғrom Ғrance into the world

Impressionism should be seen as an international art movement, not just limited to France. But Impressionist artists who did not live in France have received less than their due share of attention from art-history writers. The art-historical importance of the Italian, Ameri-

1896 — Bequerel discovers radioactivity in uranium **1896 — First modern Olympic Games in Athens**
1898 — Zola writes his open letter *J'accuse* to the President of France on behalf of Dreyfus

"it is as well not to have too great an admiration for your master's work. you will be in less danger of imitating him."

Mary Cassatt

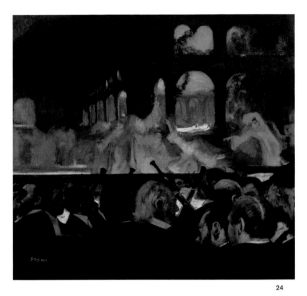

24

can and German Impressionists, while not on a level with that of the French, should nonetheless not be underestimated.

In the second half of the 19th century Paris exerted an altogether irresistible attraction on would-be artists. Many art students went to live by the Seine, and some remained there for the rest of their lives. A typical example is Giuseppe de Nittis. In 1867, the year he arrived in Paris, he was able to see, at the Exposition Universelle, the latest technical, scientific and artistic developments. The exhibition also included a major retrospective of the works of Ingres, who had died earlier that year.

It was also a special time in the context of Parisian civic history: the whole centre of the city was in the throes of re-planning and re-development. As the symbol of modern civilization, the French capital promised innovations not just at the Exposition, but throughout the re-designed streets of the city itself. The new city plan, drawn up by Emperor Napoleon III and his Prefect of the Seine, Baron Haussmann, subjected Paris to radical changes. The narrow medieval streets disappeared, whole neighbourhoods were sacrificed to the broad modern boulevards, and not least to make room for the growing population. Not just foreign artists such as Giuseppe de Nittis, who concentrated particularly on Parisian cityscapes, but local painters too were fasci-

nated by this gigantic rebuilding project. With logical consistency they made construction sites and prestigious boulevards a theme of their paintings. Even though we can detect perhaps a little nostalgia for the now-lost "old" Paris in the works of Pierre-Auguste Renoir and others, the artists welcomed the modern development.

Since the early 1860s, Paris had been the rendezvous of the international art-world. And the elegant and creative life of the city made it a focus for the rest of the world. For artists from elsewhere visiting Paris, the works of the French Impressionists were among their most important sources of inspiration. They brought the Impressionist movement back to their home countries and provided the impulse, there too, to turn away from the prevailing academic artistic ideals. Many non-French artists followed the path mapped out by their French counterparts, but arrived at different solutions of their own by dint of different preconditions in each case.

Some of the Italian and American Impressionists belonged to the Parisian circle of friends of Monet, Pissarro, Renoir and Degas, some of them displaying their works at the Impressionist exhibitions. As a result of family connections, Degas had close links with Italy and the United States, and was extremely receptive to the foreign artists in Paris. Degas' father came from southern Italy, and his mother from

1898 — Discovery of radium and polonium by Marie and Pierre Curie 1900 — Suppression of the Boxer uprising in China by the European powers

1900 — Sigmund Freud publishes *On the Interpretation of Dreams*

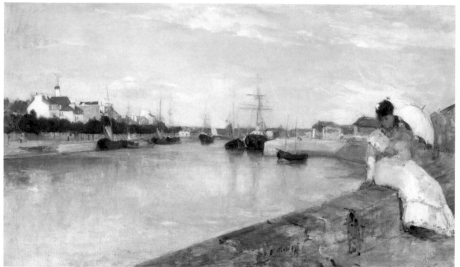

**"Real painters under-
stand with a brush in
their hand."**

Berthe Morisot

New Orleans, so that Degas himself was positively predestined to make contact with Italian and American artists. Giuseppe de Nittis, Federico Zandomeneghi and Medardo Rosso were all closes friends of Degas.

Especially following the end of the American Civil War, Paris welcomed a constant stream of American tourists, students and artists. Travel was becoming easier and more comfortable, and Europe was easier to reach. The writer Henry James noted with amazement: "It sounds like a paradox, but it is a very simple truth, that when to-day we look for 'American art' we find it mainly in Paris. When we find it out of Paris, we at least find a great deal of Paris in it." About one-third of the American visitors to Paris were women, among them the artist Mary Cassatt, who found more scope for her development here than she did back home.

"Monet is the god of the young landscape painters," wrote an American newspaper in 1891. John Singer Sargent and Monet had probably met in Paris as early as 1876 and they remained lifelong friends. In the mid-1880s Sargent experimented with the Impressionist painting technique, and worked alongside Monet in Giverny. The painting *Claude Monet Painting by the Edge of a Wood* (ill. p. 14) dates from a visit by Sargent in the summer of 1885. He acted as agent between Monet and American collectors, and himself bought a number of Monet's paintings. *Claude Monet Painting by the Edge of a Wood* he kept as a memento in his private collection. The painting depicts his friend working near Giverny. Among the trees can be seen a woman dressed in white, either Monet's partner of many years Alice Hoschedé, or her daughter Suzanne.

Paris, and this went for all the artists, was "the capital of the 19th century," as the German writer and philosopher Walter Benjamin wrote in retrospect. Following the horrors of the Franco-Prussian War of 1870/71, friendly contacts between German and French artists were rare during the 1870s. The newly formed German Empire often looked askance at French influences. Max Liebermann, for example, while he lived for some time in Paris, evidently had no personal contacts with the French Impressionists, and probably visited none of the Impressionist exhibitions. Even so, later, having returned to his home city of Berlin, he was notable for being one of the first German collectors of French art, including Impressionist works. The heyday of German Impressionism can be dated to the 1890s and the early years of the 20th century, until about the start of the First World War in 1914.

Impressionism in Germany was not concentrated in a single city as it was in France, as Berlin was still very young as a centre of the

1900 — The film *Jeanne d'Arc* by Georges Méliès is shown in France
1901 — Henri Matisse exhibits at the Salon des Indépendants

1900 — First airship flight

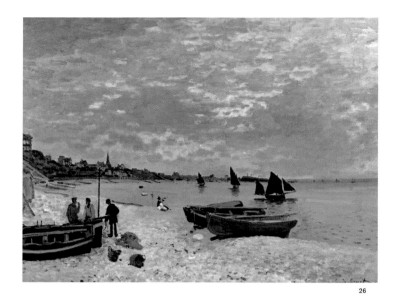

25. BERTHE MORISOT
The Harbour at Lorient
1869, oil on canvas, 43 x 72 cm
Washington, The National Gallery of Art,
Ailsa Mellon Bruce Collection

26. CLAUDE MONET
The Beach at Sainte-Adresse
1867, oil on canvas, 75.8 x 102.5 cm
Chicago, The Art Institute of Chicago

26

ts, and faced stiff competition from Munich, Düsseldorf, Weimar and resden. And also German Impressionism was not tied up with individual artist personalities, who after all did not remain Impressionists all their lives, but for whom, rather, it was merely a transitional phase. In consequence, German Impressionists have less in common than their French counterparts, and Impressionism in Germany is less homogeneous than in its homeland. Max Liebermann, Fritz von Uhde and Max Slevogt, indeed even Wassily Kandinsky were influenced by Impressionism, albeit not equally profoundly, nor equally long. All these differences from the development in France make it questionable to what extent one can talk about "German Impressionism" as a genuine movement at all. Rather, what we have are German artists who painted Impressionist pictures for a time, albeit as individuals and not as a movement.

The Moscow-born Wassily Kandinsky lived and worked in the French capital from 1904 to 1906. There, he exhibited his works in the Salon des Indépendants and doubtless also saw exhibitions of Impressionist art, which he had encountered at an early stage. Kandinsky continued his experiments with strong colours, an impulse he had received from Impressionist models. As the 20th century progressed, he abandoned figural painting entirely, and described one of

Monet's haystack pictures as the decisive factor on his road to abstraction: "I had the vague sensation that this picture lacked an object."

He and many other 20th-century artists fulfilled van Gogh's prophecy: What the Impressionists achieved by way of colour will be increased still further.

01 — Picasso begins his so-called Blue Period
1901 — Death of the painter and poster-artist Henri de Toulouse-Lautrec 1902 — Death of Émile Zola

Family Reunion

Oil on canvas, 152 x 230 cm
Paris, Musée d'Orsay

* 1841 in Montpellier
† 1870 in Beaune-la-Rolande

Frédéric Bazille came from Montpellier in the south of France. His family had wanted him to study medicine, but from 1864 supported his final decision to pursue a career in art. It was to be a short career, as he was killed in action in the Franco-Prussian War six years later. Consequently his work was not represented at the Impressionist exhibitions. But it was from him that the original idea came of holding exhibitions of one's own, where one was not dependent on the selection processes of a conservative hanging committee.

Family Reunion occupies a central place in Bazille's œuvre, because it was painted at mid-point in his career, and is the largest of his paintings still extant. In the 1860s he formed an intensive friendship with Monet and Renoir, collaborating closely with Monet in particular. Their paintings *The Beach at Sainte-Adresse* (ill. p. 25) and *View of the Coast at Sainte-Adresse* (1865, Atlanta, High Museum of Art) bear witness to this co-operation. These young painters were interested in depicting the human figure in the landscape. Together, they gathered their first impressions with open-air painting; Bazille painted his *Family Reunion* completely in the open air, as had Monet his composition *Women in the Garden* (Paris, Musée d'Orsay); all that he did later in the studio was to make detailed revisions and add himself to the group (on the left-hand edge of the picture).

The occasion for the motif was a reunion of the whole family beneath the great chestnut-tree on the terrace at Méric in the summer of 1867. Bazille's parents are seen sitting on a bench on the left of the picture. Uncle, aunt, cousins and his brother Marc with his wife are gathered on the terrace as though they had just returned from a walk together. The white, black-dotted dresses of the ladies, very similar to

those to be seen in Monet's *Women in the Garden,* were in fashion the summer of 1867. In addition, white clothing was seen as an ur mistakable sign of the bourgeoisie and bourgeois values in the 19 century.

For the painters, it was the effect of light and shade and the wa white reflected the ambient colours that was particularly interes ing. Renoir's painting *Lise with Parasol* (ill. p. 69) provides a furthe example. Bazille placed the turquoise cast of the dress of his cous Thérèse, the young woman at the table, at the focus of the compo sition. This is the actual purpose of the picture: it is not the motif whic is crucial, but the way it was painted.

Bazille's work *Family Reunion* was shown at the Salon in 186 unlike Monet's *Women in the Garden,* which was rejected by the col servative hanging committee. The young Émile Zola wrote a critique Bazille's painting, in which he emphasized three aspects: the sensiti ty of his treatment of the natural light on the terrace; the exact po traiture of eleven people, whose poses and gestures characterize the personalities; and the detailed attention paid to the clothing, whic Zola regarded as a contribution to modern life.

Eight of the eleven sitters are looking directly at the beholder, but there is no interaction between them. 21st-century beholders link this pose with a photograph, and indeed the painting has often been compared to a group photograph. Painting and photography overlapped in the second half of the 19th century. The parallel with photography highlights Bazille's endeavour to integrate narrative and the passage of time into his painted snapshot.

Claude Monet, Women in th Garden, 1867

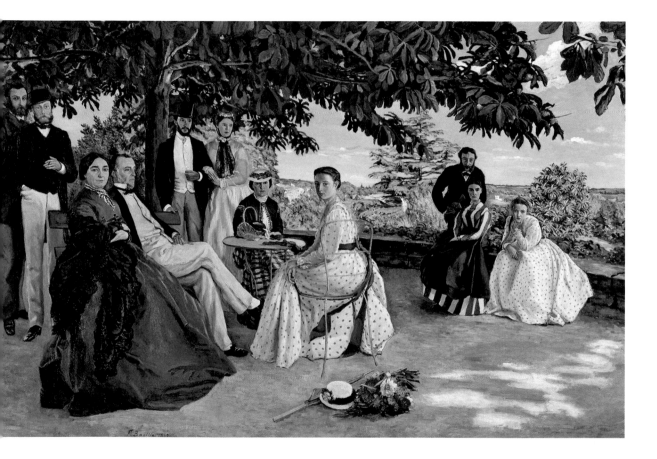

still Life with Fish

Oil on canvas, 62 x 81.3 cm
Detroit, The Detroit Institute of Arts

Still-lifes from the early days of Impressionism, in other words from the 1860s, are largely unknown today, even though almost all the Impressionist artists painted such subjects.

When Bazille decided to submit the *Still Life with Fish* for the 1866 Salon, it was because he doubted whether his *Young Woman at the Piano,* the picture originally intended for the exhibition, would be accepted. Now he sought a more moderate motif and format. He was probably inspired by one of Édouard Manet's fish still-lifes, which had been exhibited in 1865: "You cannot imagine how much I have learnt by looking at the pictures! A session there is worth as much as a whole month's work." At the same time he was also being encouraged by his friend Claude Monet to paint still-lifes. Monet recommended him to paint from nature, and above all to paint flowers. The still-lifes Monet himself was painting at this time were likewise oriented to Manet, the motifs consisting of objects arranged on a white table cloth against a dark background.

Flowers, fruit and fish were easier to get hold of than human models, who were rarely good and often too expensive. Occasionally Bazille and Sisley shared the cost by, for example, buying a dead heron which they both painted. Caillebotte reduced his costs even further by not even buying the objects, but painting them on display in a shop. With his *Still Life: Chickens, Pheasants and Hares in a Shop Window* (private collection) he brought en-

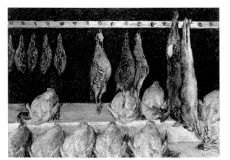

Gustave Caillebotte, Still Life:
Chickens, Pheasants and Hares
in a Shop Window, 1867

tirely new aspects to the still-life genre. A piece of modern life i reflected in the choice of a shop-display and in the depiction o a sequence. Caillebotte no longer depicts one or two fish in a domes tic setting, with a table and tablecloth in readiness for being prepare for a meal, but nine chickens, three pheasants, two hares and fiv smaller birds in a shop-window. At the same time, Caillebotte re nounces any attempt to create spatial depth. His austerely paralle arrangement of the display slab and the metal rod on which the hare and pheasants are hanging against a black background, stress th flatness of the image.

Bazille and many of his friends could not afford in the 1860s t keep buying new canvases. Instead, they would scrape off the pain from ones already used and paint them again. An x-ray examination o the painting *Still Life with Fish* has shown that the canvas had bee used for a different still-life depicting apples and pears, and wa turned through 180° before being used for this one.

One very important reason for choosing to paint still-lifes wa the hope that the conservatively-minded members of the hangin committee for the Salon exhibition would react more benevolently to wards a genre which was generally accepted and at the same tim less closely regimented. And indeed Bazille's *Still Life with Fish* wa accepted for the 1866 Salon and put on public display. The few critic who delivered themselves of an opinion stressed the successfu depiction of the fishes in the sense of their being true to nature, bu criticized the too-dark coloration. The art-critic Charles de Sarlat wrot in a short notice on 21 June 1866: "The carp is very realistic: on would like to see it on one's dinner-plate, it looks so delicious."

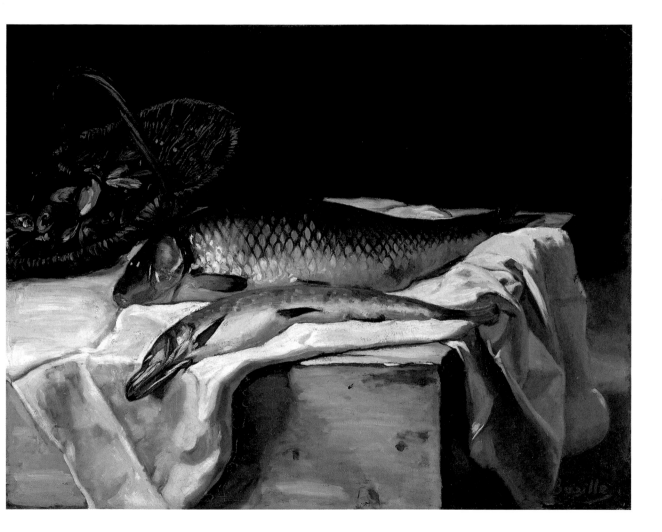

afternoon tea

Oil on canvas, 81.5 x 61.5 cm
Paris, Musée du Petit Palais

* 1841 in Morlaix (Finistère)
† 1916 in Sèvres

Alongside Mary Cassatt and Berthe Morisot, Marie Bracquemond was one of the three great women exponents of the Impressionist style. She took part in three Impressionist exhibitions: in 1879, 1880 and 1886. Today she is largely unknown, since she gave up painting in 1890 and few of her works are in public collections. This reticence was in line with the traditional role of women on the one hand, and also due, on the other, to the dominance of her husband, the graphic artist Félix Bracquemond, who was not supportive of the modernity of her painting. Evidently Marie Bracquemond finally abandoned painting for the sake of marital harmony.

Marie Bracquemond was trained by Jean-Auguste-Dominique Ingres in the Neo-classicist manner. Her second master was Paul Gauguin, whom her husband brought home in 1880, the year that *Afternoon Tea* was painted.

Afternoon Tea shows Marie Bracquemond's sister Louise sitting at a table in the open air. The open book in her hand seems not to be holding her attention, for her gaze is turned to the lower right. The frontally depicted, symmetrical, motionless face recalls portraits by Ingres, such as that of *Madame Moitissier,* which dates from 1851 (Washington, The National Gallery of Art, Samuel H. Kress Collection). The little still-life on the tea-table, in particular the silver tray with grapes, is reminiscent of similar elements in Ingres' œuvre, for example the little stool with fruit at the front edge of the painting *The Turkish Bath* (1863, Paris, Musée National du Louvre). Bracquemond juxtaposed short, closely-spaced strokes with fine gradations of red, green and blue shades in order to represent light and shade. The face and the uncovered hands are in this respect particularly sensitively depicted. The eyes and forehead are shaded by the hat, and there is a fluid transition to the lower, lighter half of the face. Individual patches of light on the clothes and the shrubs in the background are painted in pure, glaring white. The fashionable clothes, which her teacher Ingres had been wont to stage in masterly fashion, were emphasized no less strongly by Bracquemond, Bazille and for example Giuseppe de Nittis. Manet too expressed his admiration for Ingres in this regard: "Oh! Ingres was clever. We are just children. He knew how to paint textures." Ingres however only very rarely painted white clothes, Bracquemond by contrast deliberately sought out this colour.

In *Tea* (Boston, Museum of Fine Arts) Mary Cassatt's sister Lydia is drinking tea in a room with a visitor, who can be recognized as such by her hat and gloves, which were not removed for – customarily short – tea-time calls. Cassatt has spread a still-life on the table at the front edge of the picture: The silver tea-service, from which the light is reflected, plays the same role as the bright patches of sunlight in Bracquemond's afternoon scene. Cassatt's style is softer, because she used a broader brush; on the arm-chair cover, the loose brush-strokes slip in places into the abstract. The different shades of red in the wallpaper, the arm-chair cover and the table harmonize with the greyish-silver hues in the fireplace, in the tea-service and, again, in the wallpaper. Red and silver dominate, summarizing into an unusual unity. The brief impression is emphasized by the position of the cup, which is hiding the visitor's face. It is the "impression" of the moment of drinking.

Mary Cassatt, Tea, c. 1880

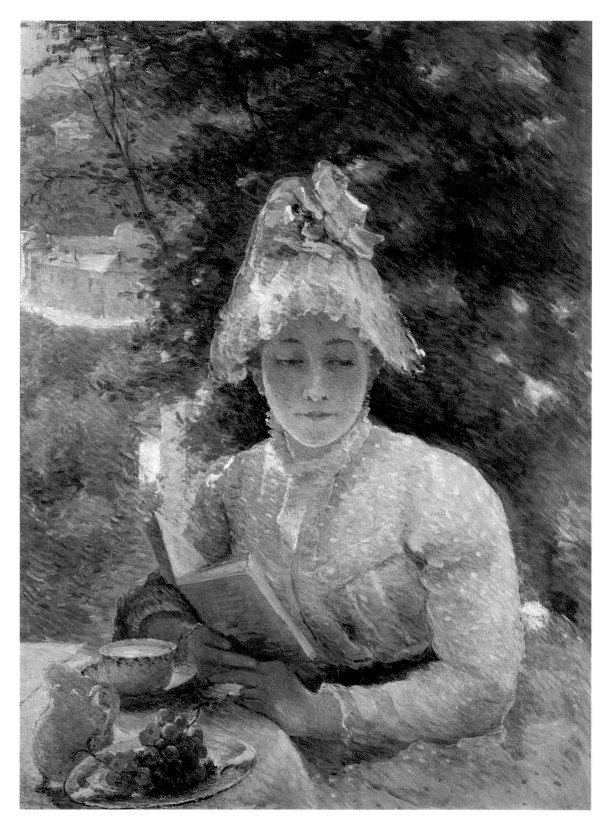

The Floor-strippers

Oil on canvas, 102 x 146.5 cm
Paris, Musée d'Orsay

* 1848 in Paris
† 1894 in Gennevilliers

Gustave Caillebotte joined the Impressionist circle in the early 1870s. He had begun to paint under the influence of Monet and his friends. At first self-taught, he then enrolled at the École des Beaux-Arts. Unlike the rest of the Impressionists, Caillebotte had substantial independent means. He could afford to support his friends by buying their pictures. The collection which he built up in this way he bequeathed to the French state on condition that a large part of it should be publicly exhibited. When he died in 1894, Renoir, his executor, had great difficulty in actually executing the will, because those in charge of cultural policy found it inconceivable to display in a museum the works of an Impressionist which the public still largely rejected. Renoir was able to transfer only parts of the collection to state ownership, including *The Floor-strippers.*

Caillebotte here depicts working men going about their business. *The Floor-strippers* can be seen in the context of similar works such as Degas' *Women Ironing* (c. 1884, Paris, Musée d'Orsay), Paul Signac's *The Milliners* (1885/86, Zurich, Foundation E. G. Bührle Collection) and *Young Woman Washing Dishes* by Camille Pissarro (1882, University of Cambridge, Fitzwilliam Museum). The Impressionists depicted urban labour alongside the rural tasks which already featured in the works of the Barbizon school. That Caillebotte, a member of the privileged haute bourgeoisie, who himself led a Bohemian lifestyle, should have chosen to depict such a motif, came as a surprise to his contemporaries. And to consider simple workers like these floor-strippers as at all artworthy, especially on a large can-

vas, was at the time a provocative innovation. *The Floor-strippers* was for this reason rejected by the hanging committee at the Salon, and Caillebotte did not, as planned, take part in the official Academy exhibition, but in the second Impressionist exhibition of 1876.

The light entering the room through the balcony door in the background produces a magnificent contre-jour effect. The light is reflected off the backs and arms of the workmen, which appear shiny as a result. The strips of remaining dark varnish on the floor glisten in the light, while the already stripped floorboards come across by contrast as matt, whether they are illuminated from the door or in the shadow of the workmen's bodies. The rhythm of the workmen seems to accord with the rhythm of the floor. The two at the front perform an identical movement and are further linked to each other by their heads, inclined in mutual conversation. Their workmate, who is further back, is cropped by the edge of the picture, thus emphasizing the snapshot nature of the depiction. His back is aligned with the horizontal line of the wood panelling and seems to be bent beneath some confining surface. These are rhythmic movement studies, comparable to Edgar Degas' ballerinas and racehorses.

Backlight and the rhythm of work are also at the focus of Monet's painting *Men Unloading Coal* (Paris, Musée d'Orsay). Barges are being unloaded on a quayside of the Seine, the dockers balancing on long wooden planks as they ply back and forth. The light is shimmering on the river, which is framed, so to speak, by the bridge spanning it. This is labour in a modern city which sets the rhythm of life. Monet and Caillebotte here present themselves as painters of urban working life, and not just of leisure.

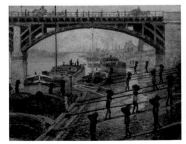

Monet, Men Unloading Coal, c. 1875

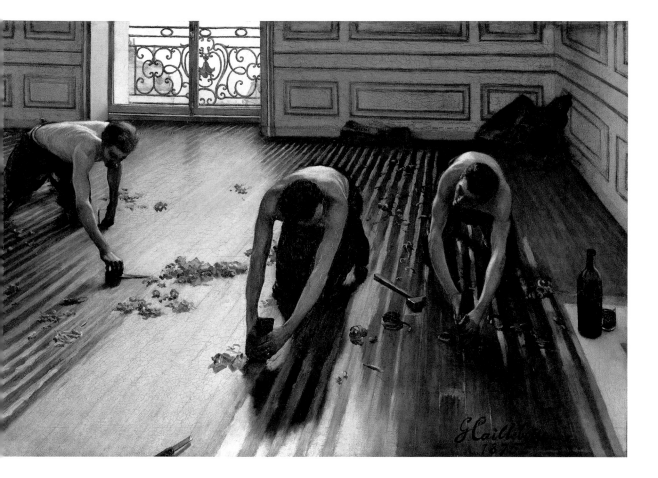

man Drying his Leg

Oil on canvas, 100 x 125 cm
Paris, Galerie Brame & Lorenceau

A man has just stepped out of the bathtub. Naked as he is, he sits down on a chair to the left of the picture, with one leg stretched out in order to be able to better rub it dry with a towel. The light-flooded room is laid out in that steep perspective which is typical of the majority of Caillebotte's paintings. The genre motif of a male nude drying himself is a snapshot of what for today's beholder is a very ordinary, everyday action. Incidentally, Caillebotte varies the theme of the man in the bathroom in a number of his works. They all display an almost too physical, perceptibly erotic quality. This is even more astonishing when one considers that Caillebotte conceived such nudes as paraphrases of 'classical' studies of the human body: One is tempted to associate a contemporary example from 1884 of a standing, bathing figure with a warrior as perhaps could have been portrayed by the French Neo-classicist painter Jacques-Louis David (1748–1825). In contrast, the athletic sitting figure in its complex posture is distantly reminiscent of the motional repertoire developed from 1504 by Michelangelo for the bathing soldiers of the (lost) *Battle of Cascina* fresco. There are many depictions of the naked male body in the history of art, but among the Greek heroes, fallen warriors, gods and images of Christ, there had been no men in bathrooms. Bathing and indeed the whole routine of body-care, in other words dressing, combing etc., was something that, as far as art was concerned, only women indulged in. Among the Impressionists too, the woman in or at her bath was a frequent motif.

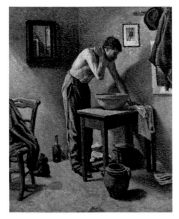

Maximilien Luce, Man at his Toilet, 1887

Degas alone devoted more than two hundred pictures to it. Caillebotte who admired Degas, had two of them in his own collection.

The male body is here being shown in a new context, thus casting into question the previously unquestioned role assignment Until the end of the 19th century, the man was seen as the conqueror the ruler, and at all levels of society and in private life as the dominant figure. As the modern age dawned, with the women's emancipation movements and the assertion in society of bourgeois values and standards such as cleanliness and personal hygiene, this traditional view of the masculine role began to falter. Caillebotte's men are modern not least because they have bath-tubs, in those days an absolute novelty in the private sphere, and only affordable for the upper middle-class.

Maximilien Luce's *Man at his Toilet* (Genevra, Musée du Petit Palais) is unable to afford this luxury. He is washing in what was then the usual way in a bowl on a wash-stand, and the other furnishings also point to his being a member of the lower classes. The Neo-impressionist Maximilien Luce took up the motif of the man at his toilet just a few years after Caillebotte, and combined it with the new painting technique developed by Paul Signac and Georges Seurat. The highly intensive coloration stands out by comparison with Caillebotte's subdued palette. Luce enhanced this dominant interplay of colours by having light enter from the side. The shadow of the man bending forward falls on the right-hand wall and forms an unusual, fascinating shape. The frame on the wall behind the man's torso, where we might expect a mirror, is revealed on closer inspection to be not a reflection and extension of the depicted room, but as a "picture within a picture," a further play with light and colours.

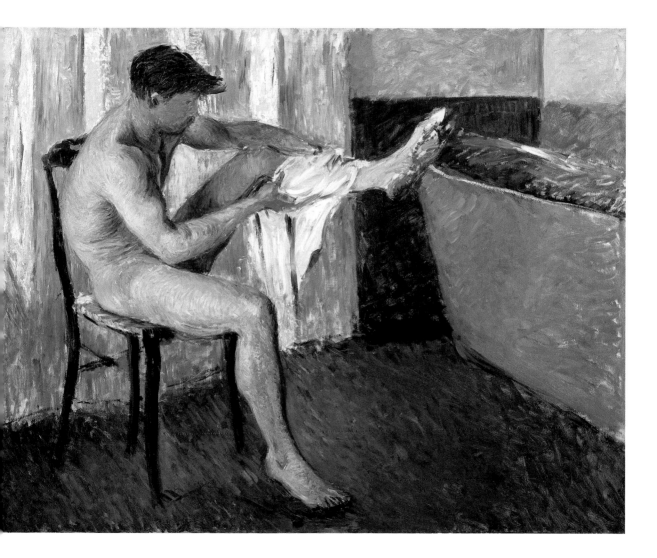

woman wearing a pearl necklace in the Loge

Oil on canvas, 81.3 x 59.7 cm
Philadelphia, Museum of Art

* 1844 in Allegheny City (Pa.)
† 1926 in Mesnil-Théribus
(near Beauvais)

Unlike Marie Bracquemond, as a foreigner in Paris Mary Cassatt had relatively good career prospects. Many American women artists reported that Paris offered them more opportunities than they had back home, where bourgeois conventions still held considerable sway.

Mary Cassatt arrived in the French capital to continue her artistic training in 1865. From 1868 she was regularly represented at the exhibitions of the Salon, and was the only American woman represented at a number of the exhibitions of the Impressionists. The painting *Woman Wearing a Pearl Necklace in the Loge* was first shown at the fourth Impressionist exhibition, where a whole room was filled by Mary Cassatt with subjects from the world of the theatre and the opera. This picture was one of the few to find a buyer at the exhibition, being sold to the French collector Alexis Rouart.

Her introduction to the circle of Impressionist painters was largely due to Edgar Degas, who had become her friend and mentor. Like Degas and Renoir, Mary Cassatt painted the major theatres and the Paris Opéra as centres of modern culture and modern life. With their evening glitz and colourful audiences, these places provided numerous motifs.

In her theatre pictures, Cassatt devoted less attention than Degas to what was happening on the stage or in the orchestra pit; she was more interested in the women in the audience. These ladies thus became objects of dual attention: first, from fellow-theatregoers, and then from beholders of the pictures. The theme of the theatre as such receded as a result into the background, forming no more than an appealing setting for the mise-en-scène of the female visitor.

Exhibiting her physical charms, be it on a walk in the park or in the audience at the theatre, was an expected part of a woman's behaviour in the late 19th century. Mary Cassatt's theatregoers seem perfectly aware of this. The fans in their hands, which could if need be provide shelter from prying eyes, remain closed. This is made particularly clear in her 1879 painting *Woman in Black at the Opera* (Boston, Museum of Fine Arts) by a man who is leaning well out of his box to look not at the lady whom he is escorting, but through his opera-glass at the opera-goer in the foreground. She in her turn is gazing at the stage through her own opera-glass. The woman in the pearl necklace is evidently also being observed by the theatregoers in the background. She though, is looking not at the stage, but at the seats in the box which are reflected in the mirror behind her. By adding a mirror directly behind the red armchair, Cassatt creates a surprising spatial effect. The elegant curve of the boxes only becomes apparent through the reflection, which also generates the strangely two-dimensional spatial effect. The radiance of the chandelier not only illuminates the lady with the pearl necklace from the front, but thanks to the reflection produces a backlight at the same time. It lights up her bare white shoulders and on her glove too, with which she is holding the fan in her right hand. The whole painting comes across as being steeped in a reddish-gold light, and can be seen as one of Mary Cassatt's most harmonious colour compositions.

Woman in Black at the Opera, 1879

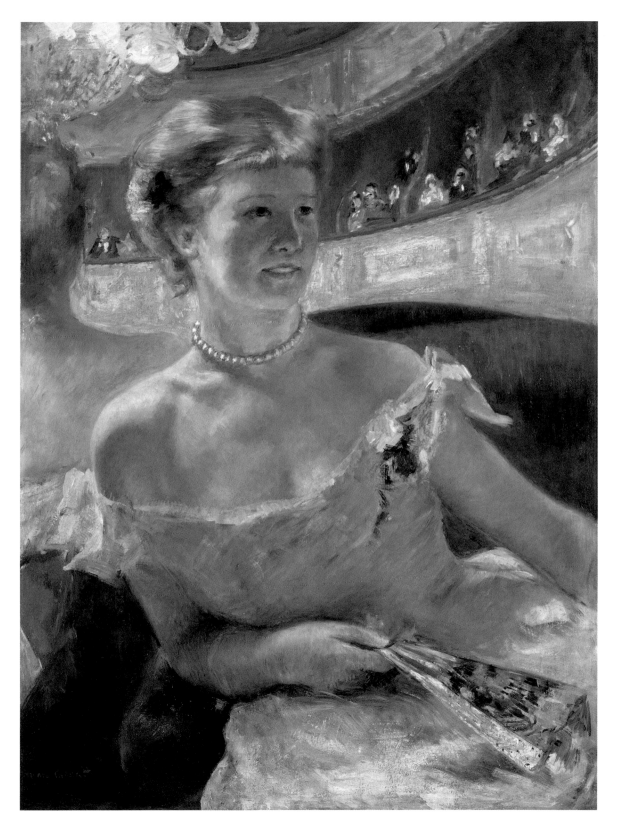

woman seated with a child in her arms

Oil on canvas, 81 x 65.5 cm
Bilbao, Museo de Bellas Artes de Bilbao

Mary Cassatt depicted women at home, in the theatre, in the park, or on the bus, but never anywhere where it was inappropriate for a lady of respectable status to be, for example a café. She herself never took part in the evening conversations and discussions held by the Impressionists, for example at the Café Guerbois. Such a place was not decent for a lady of the respectable classes to be seen in. Thus it was an exclusively feminine bourgeois world that we see through Mary Cassatt's eyes. It is their own everyday sphere that she and Berthe Morisot depict with their portrayals of mother and child.

About the Impressionists Mary Cassatt wrote: "I … must as joint initiator of the Independent exhibition stick to my principles, our principles: no hanging committee, no medals, no awards. Our first exhibition was held in 1879 and was a protest against the official exhibitions, and not a union of artists pursuing the same stylistic line. Since then we have been called 'the Impressionists', a description which may apply to Monet, but is meaningless in connexion with the name Degas. Freedom is the greatest good in this world, and the liberation from the tyranny of a hanging committee is a goal worth fighting for, for no profession is so enslaved as ours."

Mary Cassatt focuses on the depiction of the child. The mother, whose back view is further concealed by the back of the chair, is hinted at only by the bun of dark hair and her white dress. The naked infant is looking at the beholder over its mother's shoulder. The washing bowl and jug, along with some other bathroom utensils in

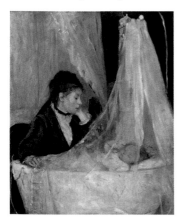

Berthe Morisot, The Cradle, 1872

Cassatt's œuvre stress the mother's attention to the cleanliness of the child, and in a figurative sense, to its purity and innocence. The infant's pinkly shimmering skin seems to reflect the mother's warmth.

Cassatt's painting technique, which she developed during the 1880s, is worthy of note. The sketchiness of the depiction is underlined by the free, rapid brush-stroke and the "unfinished" appearance of the painting. Parts of the canvas are left unpainted. We have the impression that the painter was reproducing a spontaneous, immediate impression and concentrating only on the essentials. In this work too, Mary Cassatt shows herself to be a master of red tones.

The Cradle (Paris, Musée d'Orsay), Berthe Morisot's best-known work, which was shown at the first Impressionist exhibition in 1874, concentrates on the infant's mother, the artist's sister Edma, who has pushed back the semi-transparent muslin canopy over the cradle. Supporting her head on one hand, she is looking contemplatively at the child. Morisot here harmonizes the gestures of the individual persons: the child too has placed its hand against its head. And the curtain of the cradle finds its parallel in the lace curtain in the background of the room.

In this sensitive painting, Morisot plays with shades of white. There are reddish and yellowish whites in the cradle, and a more bluish white in the window. The limpid composition is marked by the vertical line between the curtain and the wall. It is supported by the diagonal, corresponding arrangement of dark and light. Composition and coloration are thus in a very balanced relationship.

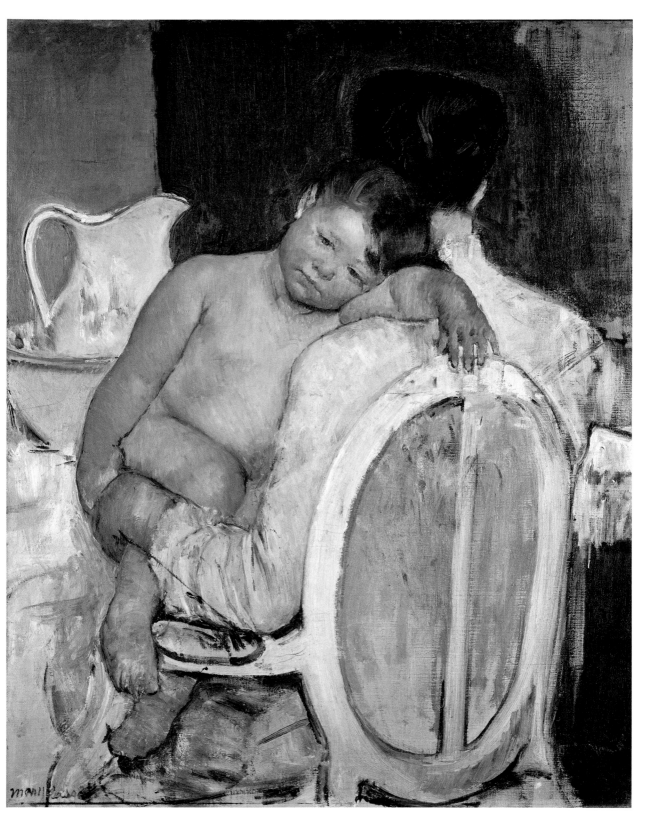

Absinthe

Oil on canvas, 92 x 68 cm
Paris, Musée d'Orsay

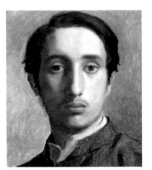

* 1834 in Paris
† 1917 in Paris

In 1876, when it was exhibited at the second Impressionist exhibition in Paris and the following winter in London, this picture bore the more harmless-sounding title *In a Café*. Degas depicts a woman and a man sitting next to each other, the woman with a glass of absinthe in front of her on the table, while the man, dressed in clothes that have seen better days, is holding a pipe. Among contemporary British art critics, the name *Absinthe* for this picture quickly caught on, obviously under the influence of a novel by Émile Zola. A well-known model, Ellen Andrée, who often worked for the Impressionist artists, and the engraver Marcellin Desboutin were the sitters here. They are depicted in the Café de la Nouvelle Athènes, a meeting-place for friends in the Impressionist circle.

Degas also depicted Desboutin as a pipe-smoker in an identical pose in a lithograph. Another painting executed the same year shows him together with their mutual friend Ludovic Lepic. A year earlier, Édouard Manet had completed a portrait of Desboutin. Manet's work *The Artist* (1875, São Paulo, Museo de Arte) shows Desboutin once again with a crushed hat pushed boldly to one side. The open white collar with a cravat loosely tied in a bow is a hallmark of all the pictures. It is only in these details that Degas keeps to Manet's original, but he turns this motif and composition into something quite different, because he does not centre the picture on Desboutin, who is placed right on the right-hand side of the picture, so much so, in fact, that he is cropped by the edge of the painting. The woman too, demoted in the same way to a marginal position, appears in some way to underline the impression of a spontaneous, immediate snapshot. The hurried brush-strokes hinting to a certain extent at clothing create the impression of a sketch.

The composition is determined by the oblique lines of the table edges and the chair back, between which the figures come across as captives. This emphatically asymmetric arrangement was inspired by Japanese woodcuts, which Degas admired. The artist makes bright light fall mercilessly and frontally on the wretchedness of the two figures, the dark shadows of their heads in the mirror seeming only to double their woe. On the table next to the woman Degas has placed a little Impressionist still-life: an empty bottle on a silver tray.

The absinthe-drinking woman has become a metaphor for the dark side of the modern age. She stands for loneliness and helplessness, the anonymity and harshness of modern city life. Shortly after the turn of the century, another modern painter, Pablo Picasso, painted the same symbolic figure a number of times. In his 1901 picture of an absinthe-drinking woman (Glarus, private collection) he comes even closer to the woman, abandoning the detachment and aloofness still palpable in the picture by Degas. Picasso's absinthe-drinker is also sitting in a café, the framed mirror on the wall providing a muted reflection of the lights in the room. On the table stands a glass filled with the green liquor, next to an empty bottle. The reflections, the harsh strong light on the woman's face, and the dominating colours all point to the young Pablo Picasso's confrontation since the 1890s with Impressionism. Already in that decade, Picasso had studied the motifs and technique of the Impressionists.

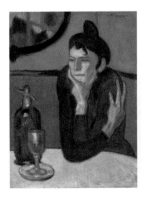

Pablo Picasso, Woman
Drinking Absinthe, 1901

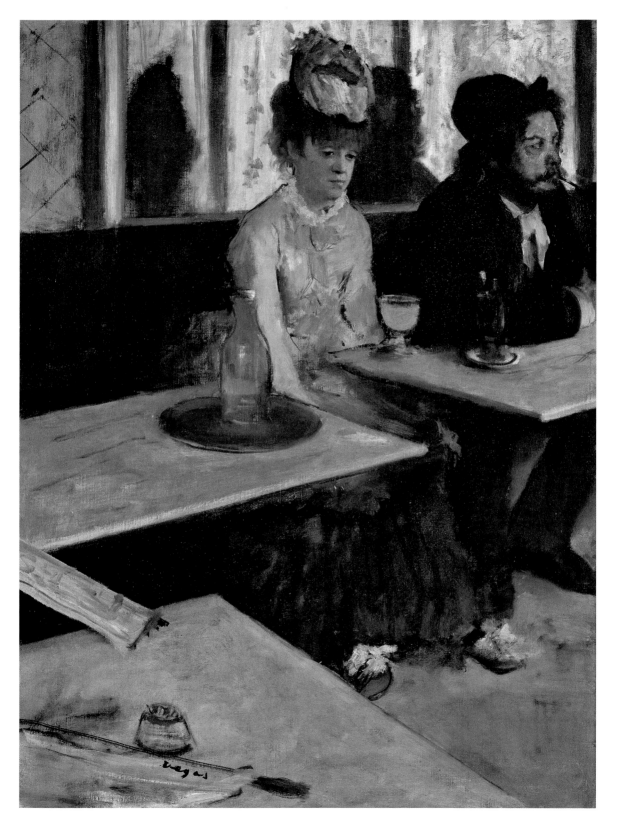

Dancer at Rest

Pastel and gouache on paper, 59 x 64 cm
Privat collection

The name Degas is, for today's art-lovers, closely linked with his numerous depictions of ballerinas. Hundreds of paintings, pastels, prints and – as here – photographs, make ballerinas Degas' most frequently chosen motif. He was fascinated by the movement of dance and the atmosphere of the stage as an expression of contemporary city life. At the same time, the grace and elegance of the ballerinas was the result of constantly repeated training and disciplined instruction. Degas shows them practising and being taught, as well as their evening performances. Their "révérences" at the close, and the subsequent exhaustion, allowed a fascinated insight into their working lives. His ballerinas need to be seen in the context of Caillebotte's *The Floor-strippers* (ill. p. 33) or Monet's *Men Unloading Coal* (ill. p. 32).

Degas was extremely open to new techniques, which aroused both his curiosity and enthusiasm. Among the Impressionists he was probably the one who experimented the most and was always most receptive to innovations. In the late 1870s he discovered a passion for photography and modern printing technologies. In addition, he executed a number of sculptures of ballerinas and devoted one of his poems to one. Degas pursued an "uninhibited pleasure in experimentation, in the unusual and also in the planned coincidence." Ingres, the Neo-classicist artist of the first half of the 19th century, for whom Degas had a profound admiration, had also used methods derived from printing techniques. He made use of the possibility of reproducing his depictions back to front, as a mirror image. Degas now integrated this into his work too. Of many of his ballerina photographs, he made, alongside a normal positive print, also a negative print and a mirror-image print.

What Degas admired most of all about Ingres was his ability to use the outlines of the body to create an almost ornamental, two-dimensional depiction. The consequence was that Ingres' paintings did not always accord with anatomical realities, but rather with his aesthetic idea. Degas once said that Ingres' importance was that he "used the formal arabesque to escape from a style of drawing which was concerned simply and solely with the correctness of the proportions …" Degas took up where Ingres left off, and, especially toward the end of his life, showed the great importance he attached to the contours of the female body. The result was ornamental, arabesque-like forms, which were continued in the Art Nouveau of the early 20th century.

Degas sought for artistic expression in the various media of his age. Movement, music and dance form an unusual sequence in this context. In his poem *Ballerina* he plays with different levels of meaning. Cythera, the Greek island of Aphrodite, is a reference to Antoine Watteau's famous painting *The Embarkation for Cythera*. Degas makes an ironic comment on the aesthetic ideas of his age when the elegant movement of the dance on points becomes a clumsy jump by a frog and the beautiful dancing-girl herself turns into an ugly frog.

Ballerina

Dying, she dances, as around the reed
of the flute where weber's sad wind is playing.
The ribbon of her steps tangles and knots.
with a birdlike gesture her body sags and falls.

The violins whistle. Fresh, from the blue of the water,
rises silvana, and curious, stretches her limbs.
The joy of new life and pure love play
on her eyes, on her breast, on all the new being.

while her satin feet embroider, like needles,
patterns of pleasure. The prancing girl
tires my poor eyes, straining to follow.

But, at a sign, the beautiful mystery ceases.
she raises her leaping legs too far.
It is the leap of a frog in the pools of cythera.

Edgar Degas

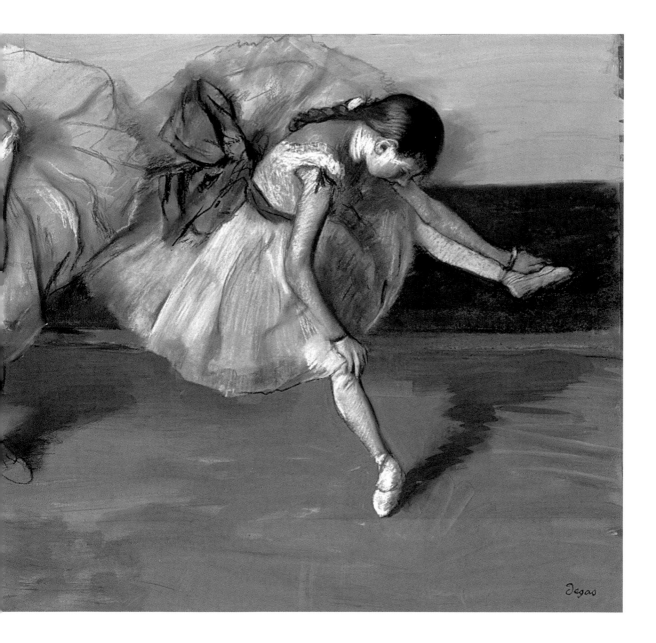

portrait of père тanguy

Oil on canvas, 92 x 75 cm
Paris, Musée Rodin

* 1853 in Groot-Zundert
† 1890 in Auvers-sur-Oise

Van Gogh painted three different portraits of his paint-dealer and friend Julien Tanguy, known to all the Impressionist artists who went in and out of his shop as "Père Tanguy." This last version dates from the winter of 1887/88. Tanguy was an important institution both for the Barbizon artists and for the Impressionists. After all, for impoverished artists he represented the only possibility of obtaining the materials they needed, for he was prepared to take their pictures in payment. In this way he also became the first collector of Cézanne's works. His shop thus became a rendezvous for the painters, and an exhibition room for their pictures, while he himself was a friend and father-figure, hence his nickname. "He's a droll, good-hearted fellow, and I often think of him," wrote van Gogh in a letter from Arles to his brother. "Don't forget to give him my regards ... and tell him, if he needs pictures for his shop-window, he can have some from here – in fact, the best." Tanguy thus had a considerable number of van Gogh's most magnificent works in his shop to sell on commission.

During the whole of his artistic activity from 1882 until his suicide in 1890, van Gogh worked with a "sensuous love of materials" and an existential urgency that reflected the existential urgency of the Impressionists before him. While Cézanne, Seurat and Pissarro slowed down the painting process in the 1880s, van Gogh accelerated it once more, and produced an incredible body of work in just a few years. "For I only have a lust for life when I work like a wild thing," he had once commented. This fast, spontaneous, immediate way of painting in a certain sense contributes to his work a strongly marked "Impressionist" aspect.

Van Gogh has composed a frontal portrait of the seated Père Tanguy, with his hands folded, a pose that he had seen in portraits by Rembrandt. The wall behind Père Tanguy is covered in Japanese woodcuts, which van Gogh had acquired cheaply from Siegfried Bing, the specialist for Japanese art in Paris. A depiction of the holy mountain, Mount Fuji, can be seen in two of van Gogh's portraits of Père Tanguy directly behind the sitter's head. The mountain comes across as a symbolic image of Tanguy's appearance and personality, above all of his dignity and humanity.

The painter Émile Bernard was close friends with both van Gogh and Gauguin. Van Gogh dreamed of a community of artists in his house in Arles. In their portraits of Père Tanguy, both van Gogh and Bernard used the divisionist method of the Neo-impressionists. They placed dots or lines in close proximity, and broke up the local colour in any one place into its individual colour components. Both artists placed their sitter in front of a wall and chose the two-dimensional pictorial space which they so greatly admired in the Japanese woodcuts.

Although Bernard depicts Julien Tanguy from much closer up, van Gogh's portrait is more intensive and penetrating. He really has succeeded in representing reality more "intensely" through the use of colour.

Van Gogh later wrote to his brother Theo: "When I am old enough, I may become like Père Tanguy. Of course I can know nothing of our personal future. We only know that Impressionism will last."

"although the painter of the future is a colourist, as there has never been before. мanet has prepared him, but you know very well that the ımpressionists have worked harder with colour than мanet."
Vincent van Gogh

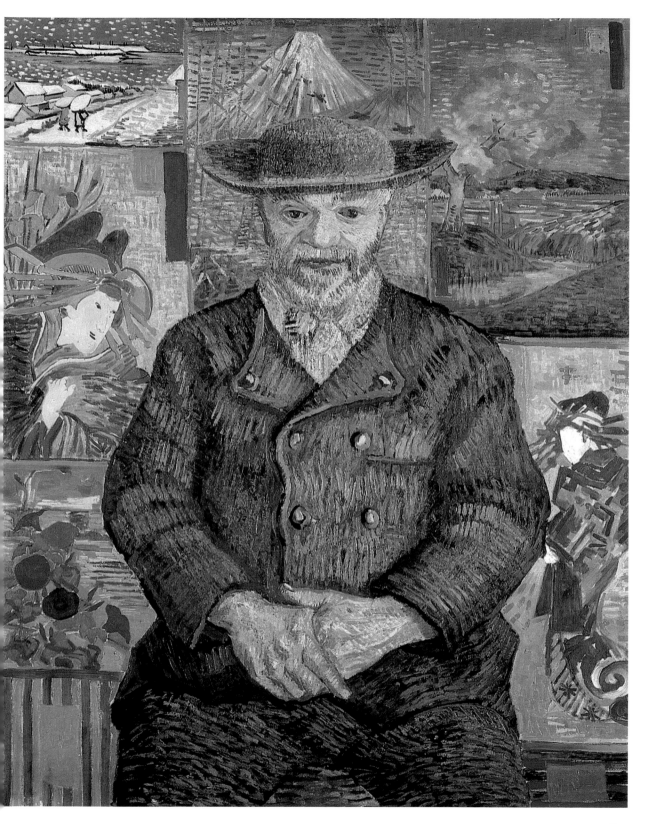

sunset at ıvry

Oil on canvas, 65 x 81 cm
Paris, Musée d'Orsay

* 1841 in Paris
† 1927 in Paris

It is a splendid sunset at Ivry that Guillaumin has depicted here. The sky is glowing reddish-orange, which merges via green into blue. The strong colours are reflected in the water too, thus creating a marked contrast with the row of black trees which extends well above the line of the horizon on the right-hand edge of the picture. Daubigny and other painters of the Barbizon school also painted sunsets in the open air, depicting the glowing colours. But while Daubigny remained exclusively concerned with nature, Guillaumin depicts the advance of the modern city in the form of the smoking chimneys on the horizon. The radical changes in the Parisian suburbs brought about by new industrial complexes and the building of workers' estates are often reflected in Guillaumin's paintings. Neither Armand Guillaumin nor one of his close friends of the 1870s, Paul Cézanne, whom he had met along with Pissarro at the Académie Suisse, were interested in the elegant life of the "grands boulevards."

Guillaumin was represented with this painting, *Sunset at Ivry,* and two more landscapes at the first Impressionist exhibition in 1874. Until 1886, he exhibited alongside the Impressionists several times. In 1873, while his fellow-artists Pissarro, Monet and Sisley depicted the creeping industrialization of the towns along the Seine if anything "en passant," Guillaumin displayed a number of unprettified views of the squalid industrial suburbs.

The painting *The Seine by Ivry,* which dates from 1869, depicts the same view of the river with the town and its smoking factory-chimneys in the background. This little oil, painted on panel, comes across as a study for the larger painting *Sunset at Ivry*. The sketchy presentation allows glimpses of the wooden panel between the greyish-brown and dirty-white clouds, so that the sky appears to be covered in ochre dabs. We have here a similar technique to that employed by Sisley in *The Watering Place at Marly-le-Roi* (ill. p. 87). This lowering impression has lifted in the paintings *Sunset at Ivry* and *Snow at Ivry*. In the latter paintings, the factories are so far away on the horizon that they are perceived as part of the riverscape.

The 1869 painting *The Seine by Ivry* found its way into the collection of the physician Dr Paul Gachet, who was friends with this artist as with the other Impressionists. He had treated Pissarro's mother in the 1860s, and, being very interested in art, maintained contact with her son. He owned a country house in Auvers, where Daubigny also lived, and used to invite artists to stay, among them Guillaumin, Cézanne and Pissarro.

Snow at Ivry was painted the same year and depicts a greyish-black building on the banks of the Seine, which in the dirty snow – it is hardly white any longer – makes a dreary impression. Only the reddish shimmer on the overcast sky betrays the low position of the sun. Nowhere is there fresh white snow with blue shadows, such as we find so enchanting in Monet's *The Magpie* (ill. p. 68) or Pissarro's *Hoarfrost, Morning (Snow in Eragny)*! In Guillaumin's *Snow at Ivry* we see not a handsome magpie perched on a fence, but a sombrely clad man in a hat, plodding his lonely way through the cold.

In the same spirit as the other Impressionists, Guillaumin seeks to present the effects of the weather and the changing light, the shadows on snow or the fading of colours in the landscape as the sun sets. But he did not choose places of leisure and pleasure in the green countryside, but rather industrial sites characterized by manual labour. Such themes were no more popular then than they are now – and it is doubtless not least for this reason that they have remained largely forgotten to this day.

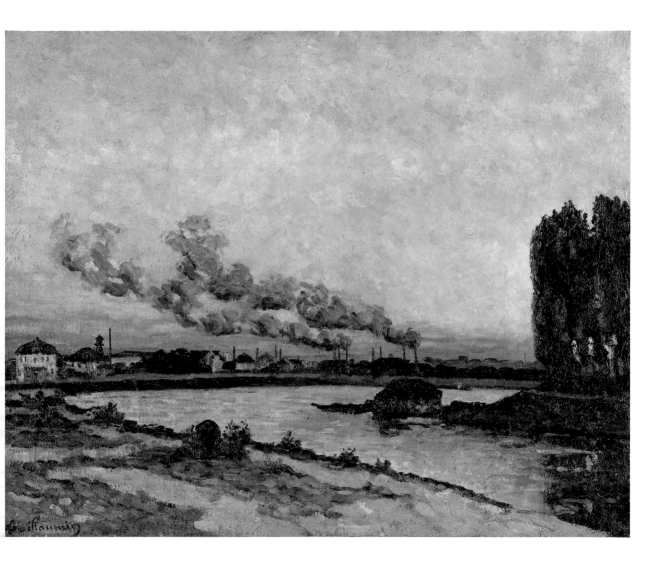

pont marie, quai sully

Oil on canvas, 59.2 x 72.5 cm
Geneva, Musée du Petit Palais, Association des Amis du Petit Palais

After taking over Charles Daubigny's former studio at 13, Quai d'Anjou in the medieval heart of Paris in 1875, Guillaumin painted numerous cityscapes in his immediate vicinity. What interested him here too, as in the previous example, was neither the picturesque old quarter of Paris nor the evening life of the cafés and bars, where the other Impressionists found their motifs, but the workaday routine on the quaysides and construction sites.

Guillaumin here presents an unspectacular detail from everyday working life. The reconstruction of Paris into the most modern city of the 19th century represented a gigantic transformation. The narrow crooked alleys were sacrificed to the "grands boulevards."

This construction site by the Pont Marie on the Quai Sully gives some impression of how such enormous building projects were implemented. A series of horse-carts are waiting in the drained river bed to be loaded with sand. A crane is piling the earth into mounds which in turn are being shovelled on to the waiting carts by workmen. The whole foreground is taken up by the drained river-bed, while the left-hand edge of the picture and the horizon are dominated by a sea of houses. The sand-sifters, who on this building-site come across as tiny matchstick-men, are recurrent figures in Guillaumin's later works.

Just a few years later appeared a series of drawings of workers shovelling loose sand through a sieve. One of these drawings is provided with a grid, an optical aid to transferring a preliminary sketch to a painting. A technique of this kind flies in the face of the Impressionist demand to reproduce a spontaneous and immediate impression. But Guillaumin lacked models – and the sand-sifters on the construction sites would not interrupt their work in order to pose for a painter. Guillaumin had to deny the basic tenet of Impressionism here in order to create a convincing work, which transcends questions of colour and light. In the course of his artistic development, it is the figure that comes more and more to occupy the centre of his attention, but he still remained faithful to the motifs which had already been choosing in the 1870s. In 1880 he depicted a building site by *The*

Pont Neuf and in 1883 he returned once more to *The Pont Marie.* In 1885 Guillaumin, in the work *The Sandpit,* devoted himself exclusively to the working men. The strong colours of the figures, above all the blue and red, contrast violently with the yellowish-brown mounds of sand. Evidently he was more concerned with the colour effects than with the depiction of the work process.

In the late 1880s Vincent van Gogh developed a great admiration for Guillaumin. "When he once visited Guillaumin in his studio, thinking the latter had not correctly reproduced the movements of the workers unloading a barge in a scene on the quay, he is said … to have represented their various postures with an imaginary spade and to have stripped to the waist, in order to demonstrate anatomical details better." By this time, the Impressionist movement having long since passed its peak, the question of the role and importance of the figure in the landscape was being answered unambiguously in favour of the figure.

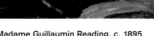

Madame Guillaumin Reading, c. 1895

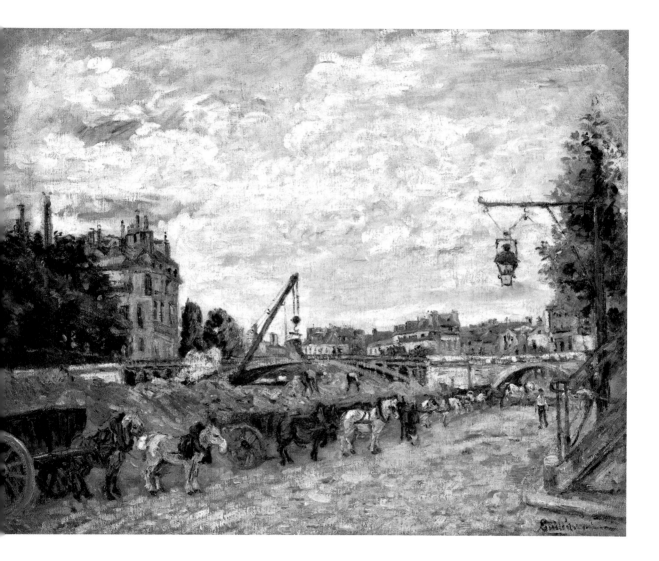

The Ludwigskirche in Munich

Oil on board, 67.3 x 96 cm

Madrid, Museo Thyssen-Bornemisza, Collection Carmen Thyssen-Bornemisza

* 1866 in Moscow
† 1944 in Neuilly-sur-Seine
(near Paris)

The missing object had disturbed him, wrote Kandinsky in reaction to his first sight of a painting by Monet at an exhibition in Moscow in 1895. The object no longer seems inevitable in a painting – for Kandinsky this was tantamount to a premonition of abstract art.

Like Kandinsky and many others, Paul Signac also made reference to Monet. Neo-impressionist art, centring on Signac, in its turn occupied Kandinsky considerably. It is possible that he had seen Signac's *Capo di Noli* (ill. p. 83) in Dresden in an exhibition at the Galerie Arnold as early as 1901 (the Russian-born Kandinsky having lived in Munich since 1896). As he himself organized exhibitions with Neo-impressionist works by Signac, including the tenth exhibition in 1904 of the artist group "Phalanx" in Munich, he was aware of both the art-theoretical and the practical consequences of Neo-impressionism. Kandinsky's colourfulness had aroused attention time and again. "Some of the most remarkable pictures are by Kandinsky. It was the time when he was still painting entirely figuratively, and came up with veritable orgies of colour effects, making serious technical studies in order to make the colours more and more brilliant and permanent …" In this aim, Kandinsky agreed very largely with Signac's ideas. This applies above all to the old-Russian motifs, which date from 1903/04, but can also be transferred to the *Ludwigskirche in Munich*: the luminescence of the colours is the crucial factor.

There is an even more far-reaching association in respect of motif between the 1904 painting *Sunday (old-Russian)* (Rotterdam,

Museum Boijmans van Beuningen) and the *Ludwigskirche in Munich*, which was painted four years later. Both works show a colourful crowd of people in front of imposing walls and a Sunday procession. The people in front of the walls of a Russian city, where an equestrian procession is taking place, correspond to those watching the procession in front of the Ludwigskirche in Munich. The two paintings show a striking similarity in the architecture depicted, which is dominated by dark, semicircular arches. There is a clear parallel between the great gates of the city walls and the Neo-Romanesque arches of the church. Kandinsky continued these arches, even more powerfully and darkly, into the landscape outside the gates of the old Russian city, while they completely dominate the *Ludwigskirche in Munich*. These almost abstract semicircular forms may perhaps contain an echo of Monet's *Haystacks.* In 1904, Kandinsky wrote to his mistress Gabriele Münter "Then I looked at the decorative sun-coloured composition I had begun. I had … taken the colours from my brief excursion of yesterday and embodied them in my imaginary old-Russian piece. Passionate deep, solemn colours, which must sound like the *ff* in the orchestra. Passionate, impudent treatment in placing them …"

Kandinsky experimented with colours like these time and again in the years to come, creating pictures with abstract, two-dimensional colour-effects like *Ludwigskirche in Munich.* The path led Kandinsky and his circle to shake off the object and to rhythmicize the picture. As with Paul Signac and Max Slevogt, there is with Kandinsky too a palpably close connexion with music. In *Sunday (old-Russian)* and more clearly still in the *Ludwigskirche in Munich* it is dark, deep organ basses that groan in the black arches, while contrasting brighter tones play in and light up the foreground. It is indeed a solemn, luminous Sunday, in old-Russia and in Munich.

The Birch Avenue in the wannsee garden, looking west

Oil on canvas, 85.5 x 106 cm
Hannover, Niedersächsisches Landesmuseum

* 1847 in Berlin
† 1935 in Berlin

The year this view of the birch avenue in the garden of Liebermann's country house in the Wannsee suburb of Berlin was painted, the art-critic Julius Elias published a volume titled *Max Liebermann zu Hause* (Max Liebermann at Home). The book contains a series of drawings and etchings of his family by Max Liebermann himself, and there is also a view of his summer retreat with its garden by the lake. The dedication of the book to 20 July 1917 is a reference to Max Liebermann's 70th birthday. The focus of the author was on Max Liebermann the private individual, for "here, he is a family man, and not just in that socially restricted sense … If his art imagines a power that explains the world – unphilosophically, unsensationally, untendentiously – then this little sketchbook also explains a world, HIS world, a kind of remote island … If he sought in his art intimacy above all, then he was perhaps at his most intimate in these unassuming "occasional poems," which paraphrase his view of the poetry of nature and of man so serenely and so purely." In Barbizon in the summer of 1874 Max Liebermann himself had explained his goals as follows: "I sought intimacy in the picture."

In his youth Liebermann had sojourned not just in Barbizon, but also for a time in Paris, but at that stage had not made any contact with the Impressionist artists. Instead, he oriented himself to Dutch painters such as Franz Hals and Rembrandt. Édouard Manet's garden pictures, a few of which Liebermann himself possessed, also probably had an influence on him.

Liebermann's painting of the *Birch Avenue in the Wannsee Garden, looking West* is one example from a whole series of garden pictures which the artist executed at around this time. "One could pain[t] hundreds of pictures here," he enthused.

Liebermann turned relatively late to Impressionism, long after i[t] had passed its peak. In the *Birch Avenue in the Wannsee Garden* s[o] many Impressionist aspects are addressed that one could justifiabl[y] talk of "German Impressionism." The dominance of light and colour i[n] the treatment is articulated most strongly during this particular perio[d] of Liebermann's creative life.

Liebermann's garden by the Wannsee lake was laid out in th[e] years after 1909. Monet's and Liebermann's gardens are totally dif[-] ferent, Liebermann preferring a more austere layout of beds, whic[h] were bordered with box hedges. In Liebermann's garden, in which unlike Monet, he never worked as a gardener himself, there were non[e] of the meandering streams or luxuriantly blossoming hedges s[o] beloved of Monet.

In his compositions, Liebermann always directed the gaze o[f] the beholder across a number of flower-beds in order to take accoun[t] of the total geometric layout of the garden. The integration of th[e] numerous birches is due to his "veneration of the local and of nature[."] The wooded Brandenburg landscape is thus integrated into the gar[-] den. Trees and hedges give rise to different scenarios, which allow[s] constant succession of new glimpses. The garden is depicted not jus[t] as a place of leisurely enjoyment, as an addition to the modern, urba[n] lifestyle, but as a place of recuperation from the hectic life of the cit[y.] Sometimes someone is sitting reading on a bench or going for a wal[k] while a child is playing under the eye of the governess. In Lieber[-] mann's pictures, the yearning for idyll and tranquillity is palpabl[e] against the background of city life.

> "Art is life and life has become art. old art or new art:
> the only enduring aspect of it is that which is living!"
> **Max Liebermann**

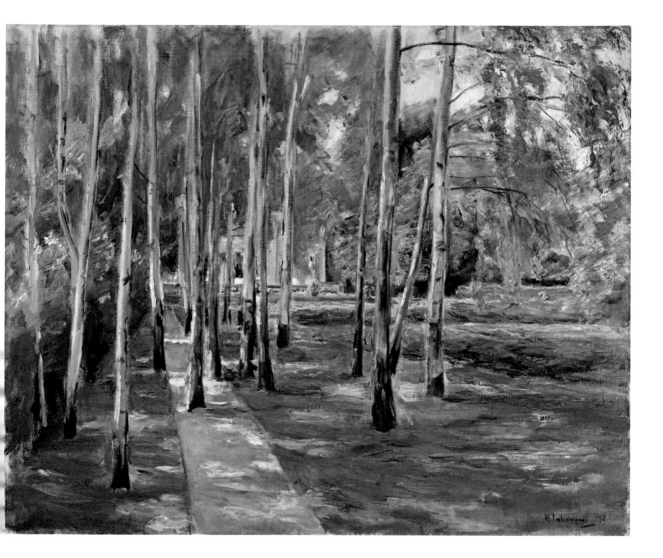

Le Pont de l'Europe

Oil on canvas, 64 x 80 cm
Paris, Musée d'Orsay

* 1840 in Paris
† 1926 in Giverny

"This year Monet has exhibited magnificent interior views of stations. In them one can hear the hissing of the arriving trains, one sees the steam pouring out and being stirred up in the spacious train-shed. This is painting's place today … Just as their fathers discovered the poetry of the woods and rivers, our artists today must discover the poetry of railway stations."

Émile Zola, the great French writer and friend of the Impressionists, wrote enthusiastically of the seven station motifs that Monet displayed at the third Impressionist exhibition in 1877. Of the total of 250 paintings exhibited, very few were sold. During these decades, the railway station and the railway as such had become the symbol of speed and mobility, indeed of modern life. Édouard Manet, Gustave Caillebotte and many other artists devoted themselves to this motif. In about two months Monet painted twelve views of the Gare Saint-Lazare and the neighbouring bridge, the Pont de l'Europe. He himself lived with his family very close to the bridge and the station in the rue Moncey. The hoped-for artistic recognition was some time in coming, and Monet found himself in financial difficulty. His friend Renoir wrote in relation to this period: "Monet stood above all the changes and chances of life. He put on his best clothes, arranged the lace of his cuffs, and, casually swinging his cane with the gold pommel, handed over his visiting card to the director of the Western Railway line at the Gare Saint-Lazare. The official at the door stiffened, and led him in immediately. The lofty personage asked the visitor to take a seat, whereupon the latter introduced himself with great simplicity: 'I am the painter Claude Monet.'"

Monet was interested above all in the light effects produced by the steam and smoke. That's why he depicted the locomotives going up and down in the train-shed and under the Pont de l'Europe. In this way he produced his own poetic image of modernity. The fact that it was a staged picture did not bother him overmuch. Monet's station pictures are neither authentic, spontaneous impressions nor exclusively open-air painting. His works are the result of precise observation and construction, and not at all as snapshot-like as they appear.

Numerous preliminary sketches for the paintings of the Gare Saint-Lazare and the Pont de l'Europe have been preserved, and they show how considered and unspontaneous the paintings were. Monet's painting *Le Pont de l'Europe* lives from the tense contrast between the austere geometric form of the stone and iron bridge, and the moving smoke and steam dissolving in the hazy sky. The locomotive pushing into the painting brings a targeted movement from left to right and thus crosses the diagonal formed by the bridge and the ensuing canyon of the street. The crossing area is additionally emphasized by the two pillars of the bridge. Monet's art of composition is particularly apparent here.

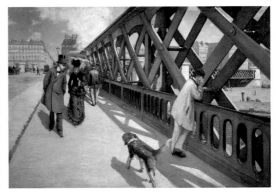

Gustave Caillebotte, Le Pont de l'Europe, 1876

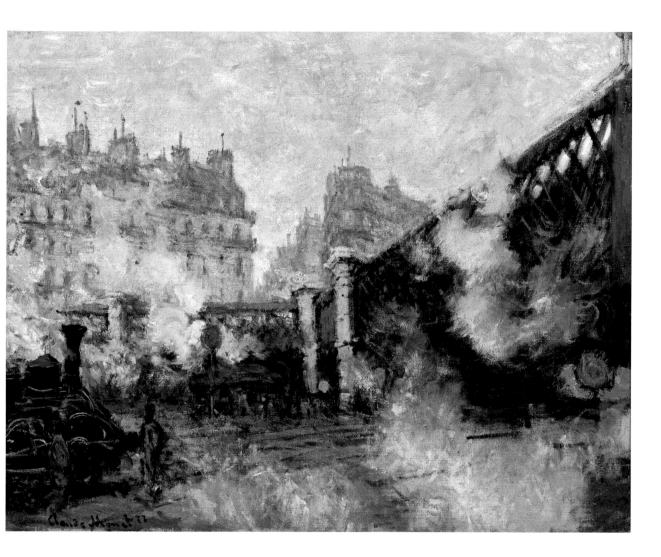

The Artist's garden at vétheuil

Oil on canvas, 150 x 120 cm
Washington, The National Gallery of Art, Ailsa Mellon Bruce Collection

Claude Monet often moved house in the course of his life. But there was only a garden in those houses where he stayed for any length of time: in Argenteuil, Vétheuil and later in Giverny. Monet's famous garden in Giverny often leads us to forget that his concern with gardens and flowers did not begin there. As early as the mid 1860s, when Monet painted his first still-life with flowers, he wrote to his friend Bazille: "There are at the moment some very beautiful flowers … why don't you paint some too, I think it's an excellent thing."

Such "excellent things" sold well in those days – an important aspect in view of Monet's chronic shortage of money. Between 1882 and 1885, the art-dealer Durand-Ruel ordered 36 still-lifes from Monet, some of them intended for his private apartment. The Monets had lived since the autumn of 1878 in Vétheuil, a small village on the Seine to the west of Paris. The decidedly rural ambience provided a welcome contrast to the hustle and bustle of the city. Monet reported enthusiastically of the "enchanting surroundings," which he depicted in *Plum Trees in Blossom in Vétheuil* and *Poppy Field near Vétheuil* (1879, Zurich, Foundation E. G. Bührle Collection). Above all his 1881 picture *Field of Wheat* (Cleveland/Ohio, Cleveland Museum of Art) displays the saturated colours of the broad plain of the Seine in high summer.

Monet's second son and youngest child was six months old when his wife Camille fell seriously ill; she died a year later, in September 1879. Alice Hoschedé,

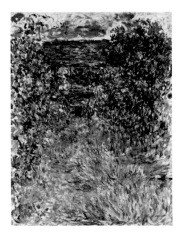

The House Among the Roses, 1925

the former wife of Ernest Hoschedé, a friend of Monet's, had moved in as Camille's nurse. She brought the six children from her first marriage into the Monet household, and later became Monet's second wife.

A journalist once asked Monet about his studio in Vétheuil, and Monet answered: "My studio! But I never had one, and I don't understand how someone can shut themselves in a room – maybe to draw, but not to paint." Nonetheless, Monet did not just follow the Impressionist ideal of "plein air," but also sometimes withdrew to his studio to work. In Vétheuil, it is true, his studio was, on account of the large number of people living in the house, confined to a small room in the attic.

The garden lay right next to the Seine, falling away to the river. A flight of steps led from the house to an orchard on the bank. The Seine here was polluted by the sewage of the city of Paris, which was discharged at Asnières, but as a result full of nutrients, which favoured luxuriant vegetation.

In four paintings, Monet chose the perspective from the lower section of lawn with the steps as the central axis of the picture. The view of the steps, with the giant sunflowers in bloom and the red gladioli in blue-and-white flowerpots allowed him to integrate an energetically rising movement into his arrangement. The gaze of the beholder automatically follows the steps upwards and is then led on with the help of the chimney, which is outlined against the sky as a continuation of the same line, ending only just short of the edge of the picture. Precisely on this line, standing at the foot of the steps, is the youngest inhabitant of the house, the four-year-old Jean-Pierre Hoschedé.

This picture also reflects the comment of Émile Zola: "In the fields, Claude Monet prefers an English park to a bit of forest. He likes finding traces of people everywhere. … Like a genuine Parisian, he prefers Paris to the countryside, he is incapable of painting a landscape without introducing a few well-dressed ladies and gentlemen."

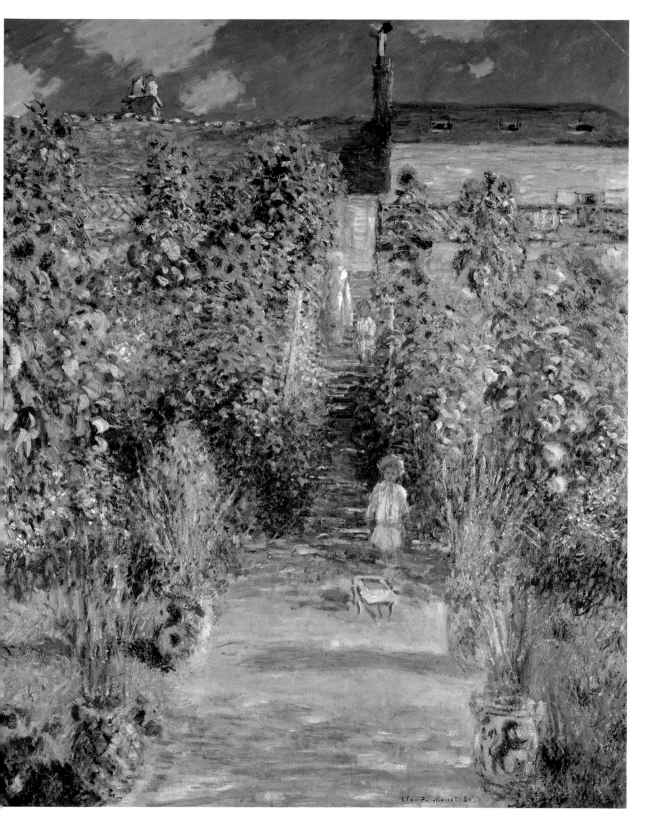

psyche

Oil on canvas, 65 x 54 cm
Madrid, Museo Thyssen-Bornemisza

* 1841 in Bourges
† 1895 in Paris

Of the eight paintings that Berthe Morisot completed in 1876, four of the paintings show a woman at her toilet. Of these, she only gave one a title, namely *Psyche,* one of the paitings goes beyond a merely objective identification of the motif. Berthe Morisot exhibited the canvases *Psyche* and *Young Woman Powdering her Face* (1877, Paris, Musée d'Orsay) at the 1877 Impressionist exhibition. On this occasion Renoir and Caillebotte expressed their appreciation of the artist by writing: "We count ourselves fortunate in the thought that you wish to participate as usual."

Young Woman Powdering her Face was bought by the collector and patron Ernest Hoschedé and later auctioned together with the rest of his Impressionist collection. Mary Cassatt took the opportunity to purchase the painting, which she doubtless especially liked in view of the closeness of the motif to her own work.

Morisot's *Psyche* shows a young woman looking at herself in a large mirror. As the mirror is evidently placed on a wall between two windows, the scene is fully illuminated, indeed flooded with light. The woman is submerged in her contemplation of herself. She is opening a fastening on the back of her corset, while one sleeve is already slipping over her shoulder. The brush-strokes are very loose. Dabbed and dotted shapes hint at a carpet-pattern, while the sofa in front of the back window, and the mirror itself, are equally lacking in sharpness. The tall frame of the mirror, which is cropped by the top edge of the picture, provides a "picture within a picture," recalling Degas' depictions of ballerinas.

With the title *Psyche* Morisot makes reference to the classical myth of Amor and Psyche, whose episodes were depicted time and again over the centuries. The extensive reception-history of this myth always saw a more profound meaning beneath the surface of this ancient fairy-tale. The 19th century Psyche, whose own symbol was a butterfly, was seen first and foremost as the symbol of the immortal soul. This soul, which underwent metamorphoses just like a butterfly, was often depicted as a young woman with butterfly-wings. In Morisot's painting we can see a hint of this in the position of the arms. Morisot's *Psyche* does not, however, come across as a figure from classical mythology. The protagonist is, rather, a contemporary who is questioning her reflection. Nor is there any trace of Amor, her classical lover.

Certainly though, the image of the soul whose fate is closely tied up with the joys and sorrows of love was particularly applicable to Berthe Morisot at this time. In 1874 she had married Eugène Manet, the younger brother of Édouard, and thus embarked on a new phase in her life. Her attempts at combining marriage and, later, motherhood with her career proved difficult. In 1890 she recorded in her diary: "The truth is that our value lies in feeling, in intuition, in our gaze, which is more subtle than that of men. We can achieve something, provided we do not spoil it all through affectedness, pedantry and sentimentality. ... I should like to fulfil my duty [to my work] until I die; I wish the other wouldn't make it so difficult for me."

"in love, there's sentiment and passion;
i know only sentiment through myself, passion
through others. i hear certain voices i know say:
sentiment = love of the intellect; i can answer:
passion = the love of the body."

Berthe Morisot

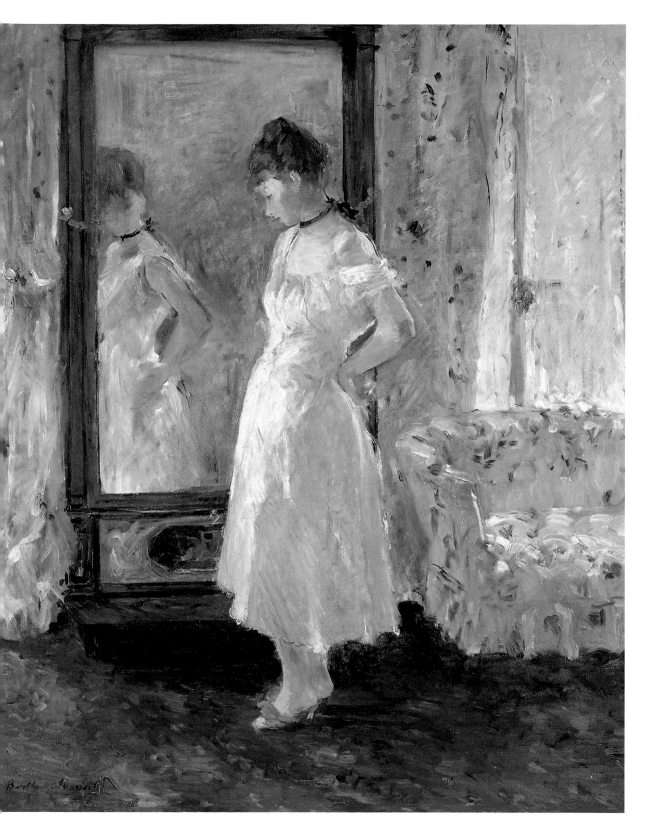

summer's Day

Oil on canvas, 45.7 x 75.2 cm
London, The National Gallery

Berthe Morisot's œuvre contributed no less to the innovations of Impressionism than did the paintings of Pissarro, Renoir, Sisley or Monet. And yet in art history she is often mentioned merely as an adjunct to her friend and mentor Édouard Manet.

The painting *Summer's Day* is believed to be one of four seasonal paintings she planned together with Manet, who, while he executed *Spring* and *Autumn,* chose in each case a personification that differed greatly from Morisot's motif *Summer's Day.* We can therefore exclude any connexion.

Morisot's independent and unusual painting technique has not been properly appreciated. She places paint on the canvas with enormously free brush-strokes, with the result that the finished work also has thicker dabs of paint. She thus creates an irregular skin of paint, which is far removed from the academic smoothness of traditional painting. With disconnected brush-strokes and energetic zigzags, Morisot does what the light and colour tell her. In addition she formulates gender-specific aspects with highly personal motifs.

Berthe, who had given birth for the first time the previous winter, would accompany little Julie and her nanny on their daily walks in the park. The Bois de Boulogne stimulated her to start painting once more in the open air. She found an ideal compromise between her maternal duties and the desire to take up painting again as quickly as possible. By summoning her models to the park, she could paint them there and at the same time be together with Julie.

Morisot's painting *Summer's Day* depicts a sunny scene by the water. One of the lakes in the Bois du Boulogne, where the Parisians came to escape from the city, is being used by two women for a boating expedition. Renoir chose a very similar motif for his painting *Boats on the Seine* (ill. p. 71). On Morisot's canvas two women are sitting in a boat that occupies the entire foreground. Optically, Morisot is very close to them. In comparison with Renoir's painting *Boats on the Seine,* it is clear the extent to which the painter concentrates on the figures; Renoir by contrasts treats his as merely part of the landscape.

Morisot does not capture a spontaneous view of two women waiting for the boat to push off, but offers a well thought-out composition for which she executed a preliminary watercolour study. This study presents the motif in almost identical fashion and was very probably actually done in the Bois de Boulougne. Morisot used two professional models who also worked for Édouard Manet, who had recommended them to her. She painted them on a second occasion, too, this time picking flowers in the Bois de Boulogne.

The artist exhibited the works she had painted this summer at the 1880 Impressionist exhibition, and was heaped with praise. She was even able to sell a few paintings. Some critics compared her treatment of colour to that of the great 18th-century French painter, Jean-Honoré Fragonard, to whom she was related. "Look how wonderfully she always deals with the white in her paintings; no one has ever used white so extraordinarily." The art-critics called her a "fundamental unrepentant Impressionist."

"mademoiselle morisot has an eye for extraordinary sensibility."

George Rivière

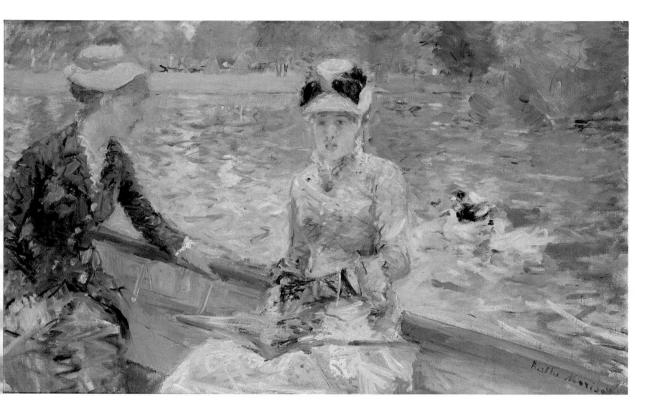

Flirt

Oil on canvas, 33 x 43 cm
Private collection

* 1846 in Barletta
† 1884 in St.-Germain-en-Laye

Born in southern Italy, Giuseppe de Nittis came to Paris in 1867. He quickly became a familiar face on the Parisian art scene. He succeeded in interesting two reputable Paris art dealers. Franz Reitlinger was the first to conclude a contract with him, and at first De Nittis had to bow to his will, hence the so-called costume paintings, which were "en vogue" at the time. In 1871 de Nittis changed to the firm of Goupil & Cie.

De Nittis turned to landscape painting, spending several weeks in southern Italy with his friend Gustave Caillebotte. Already there he developed a decidedly spatial approach in his compositional technique. The strong, space-creating lines influenced other artists, not least Caillebotte in his painting *Le Pont de l'Europe* by the Gare Saint-Lazare (ill. p. 54). Van Gogh, too, found the treatment of space so remarkable that in 1875 he made a drawing of De Nittis' painting of Westminster Bridge in London.

Only once – in 1874 – did De Nittis take part in an Impressionist exhibition, being represented with five paintings. Renoir, who did not think De Nittis should have been admitted, considering him too conservative and his art purely commercial, had hung his works in very unfavourable positions. When the Italian was awarded the order of the "Légion d'honneur" in 1878 for his services to art, he also had to endure harsh criticism from his friend Degas, who denounced him as "bourgeois."

Flirt is one of many paintings by De Nittis that depict the Parisians at the races. Unlike Degas, who was more interested in the movements of the horses and the gesticulations of the jockeys, in all these De Nittis put the focus of his composition squarely on the spectators.

Thus also in *Flirt*. Anecdotally, the picture describes the goings-on on the fringes of the main action. A young couple in the foreground have remained seated while the remaining spectators have left the shady seats. The scene is embedded in the cheerful atmosphere of a Sunday race-meeting, while at the same time the two persons are so isolated from the crowd that the narrative concentrates entirely on them. The broad tree-trunk on the left-hand side of the picture marks the foreground, which is cast in the shade of the foliage. The sunny background is marked out by a row of posts. The spatial perspective runs along an energetic diagonal from front left to back right. It corresponds to the gaze of the flirting couple towards the two women who are strolling by on the right-hand edge of the picture.

Typically, De Nittis has not given us a photographically exact reproduction, but rather reinforces the poetic character of a scene. He was working for a balance between authenticity and poetry, which was sometimes called "poetic realism."

> "For me, Paris in snow is like a vision of Japan, an imagination of that dolce vita of a dreamer for whom a string of white things is sufficient. A squall of snow, a sea of flowers. This is the life for which I was born, painting, admiring, dreaming."
>
> Giuseppe de Nittis

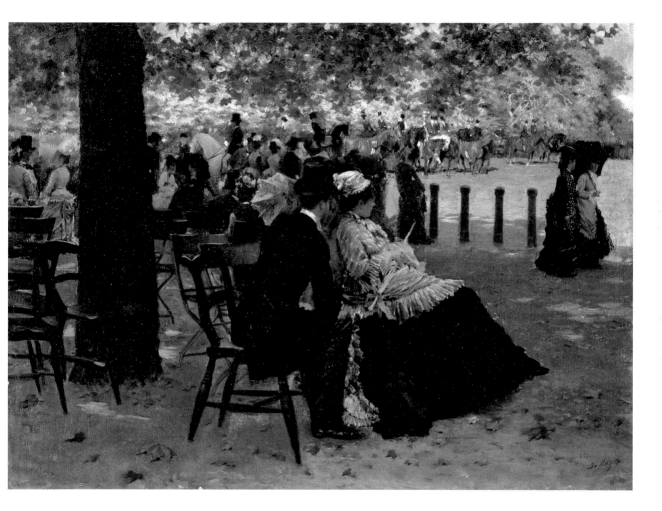

Hoarfrost

Oil on canvas, 65 x 93 cm
Paris, Musée d'Orsay

*** 1830 in Charlotte-Amalie**
(Danish Antilles)
† 1903 in Paris

In 1866 Camille Pissarro moved with his family to near Pontoise. Some 30 kilometres to the west of Paris on the banks of the Oise, he found rural scenes and fresh motifs, such as the *Hillside of the Hermitage, Pontoise* (ill. p. 11). Pissarro and his friends painted numerous landscapes in the region. With Cézanne in particular, Pissarro worked together a great deal at this period. In October 1873 the Pissarros moved to the rue de l'Hermitage in Pontoise. Pissarro painted a whole series of works to familiarize himself with the immediate surroundings, one such work being *Hoarfrost*. The painting was shown at the first Impressionist exhibition in 1874, which was violently panned by the art-critics. Pissarro reacted by saying: "The critics are tearing us to shreds, accusing us of learning nothing. I'm returning to my work, that's better than reading [reviews] that teach us nothing."

Pissarro understood his artistic work as a learning process. His predilection was for tapering paths in the landscape. His works are not narrative: they depicting not events, but states. The views come across as unspectacular, as though the motif were randomly chosen. *Hoarfrost* shows a broad ascending path lined on either side by fields. A country-dweller with a bundle of brushwood on his back and a stick in his hand is walking up the path. Maybe Pissarro was thinking of Millet's depictions of figures gathering firewood.

Pissarro has placed the line of the horizon very high, so that the hill appears to be relatively steep. The individual bare trees, the haystacks on the horizon and the vanishing path generate a hilly, lonely landscape. Pissarro painted motifs like this time and again, not least in his graphic work *Rain*. What makes *Hoarfrost* and *Rain* particularly interesting are the various lines and diagonals that determine the structure of the picture. *Hoarfrost* works with a path, crossed by long, dark shadows, running into the depth of the pictorial space. The shadow-lines stretch across the whole landscape and in the right foreground of the picture they form a grid with the furrows of the ploughed field. *Hoarfrost* is distinguished in particular by the geometric experiments that Pissarro integrated into his works at this period.

The connoisseur Théodore Duret wrote to Pissarro: "You have … a profound inner feeling for nature and you handle the brush powerfully, so that a picture by you is something absolutely definitive … pursue your own road, that of rural nature. You will travel a new road, just as broad and lofty as any master." Pissarro replied: "I would like you to know that I have been thinking for a long time about what you say to me. What prevented me for so long from directly depicting nature was quite simply the availability of models, not just for painting the picture, but also for studying the subject seriously. As for the rest, I will not hesitate to try it. It will be very hard, because you should know that these pictures cannot always be painted directly in front of nature, but only after it."

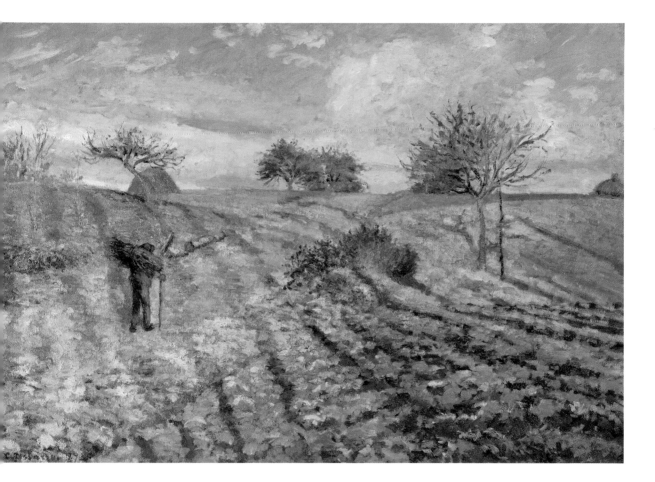

The Pork Butcher (La charcutière)

Oil on canvas, 65.1 x 54.3 cm
London, The National Gallery (loan from the Tate Gallery)

Pissarro had been painting market scenes such as we see in *The Pork Butcher* since 1881. *The Pork Butcher* is accompanied by *Potato Market in Pontoise* (1882), *Poultry Market in Gisors* (1889) and *Grain Market in Pontoise* (1893). All these paintings depict numbers of people trading, chatting, debating, tasting, buying and selling. Pissarro reported on his work in July 1883: "I have not worked much outside this season, the weather was inclement, and I am pursued by the thought of painting particular figure-pictures with whose conception I am struggling. I make a kind of little cartoon, and when I've thought the thing through properly, I set to work. Nini [Pissarro's niece] sat for me as the "charcutière" in the wind on the Place du Grand Martroy, and I hope it exudes a certain juiciness. The problem is the background. We'll see."

The composition was, then, well thought-through, and Pissarro shows himself, in humorous fashion, concerned to express a commonality between the goods and the woman selling them. Both the person and the ham she's selling should exhibit a "certain juiciness." The harmonization of colour in red and white shades, in any case, right down to the butcher's clothes, is successful. With the hustle and bustle of the market scenes Pissarro returned to a theme which had already occupied him at the outset of his artistic career.

Camille Pissarro was born on the island of St Thomas in what was then the Danish Antilles and now forms part of the United States Virgin Islands. The Jewish Pissarro family came from southern France to the capital of the Danish Antilles to engage in the flourishing trade between Europe, South America and the United States. Camille worked in his father's business for some years, and consequently had first-hand experience of commercial life. He had been an enthusiastic draughtsman since his youth, and his first motifs were vibrant markets and the market-women calling their wares.

His birthplace, his Jewish ancestry and the experiences of his youth all meant that Pissarro lived in opposition to the spirit of the age, and refused to bow to social or artistic conventions. His capacity for prolonged resistance to social pressure and to organize a group of artists to hold joint exhibitions made him the core of the Impressionist movement. His background also contributed to his political attitude. Pissarro was "an anarchist through and through." His depictions of peasant life have, then, nothing to do with any purported socialist ideals. Pissarro was not a precursor of "Socialist Realism." Maybe it was only logical that in the 1880s, when the Impressionist movement entered a crisis, he should return to the motifs of his youth and thus to the wellspring of his strength. The artistic views of his Impressionist friends were becoming gradually incompatible and the joint exhibitions came to an end in 1886. What Pissarro wrote about this can be understood as his motto: "As far as I'm concerned, I will stick by my right to pursue my path freely."

"I forgot to tell you that I found a room in the Grand Hôtel du Louvre with a superb view of the Avenue de la opéra and the corner of the Place du Palais-Royal. It is very beautyful to paint. It may not be aesthetic but I am delighted to be able to paint these Paris streets that people find ugly but which are so silvery, lively and bright."

Camille Pissarro

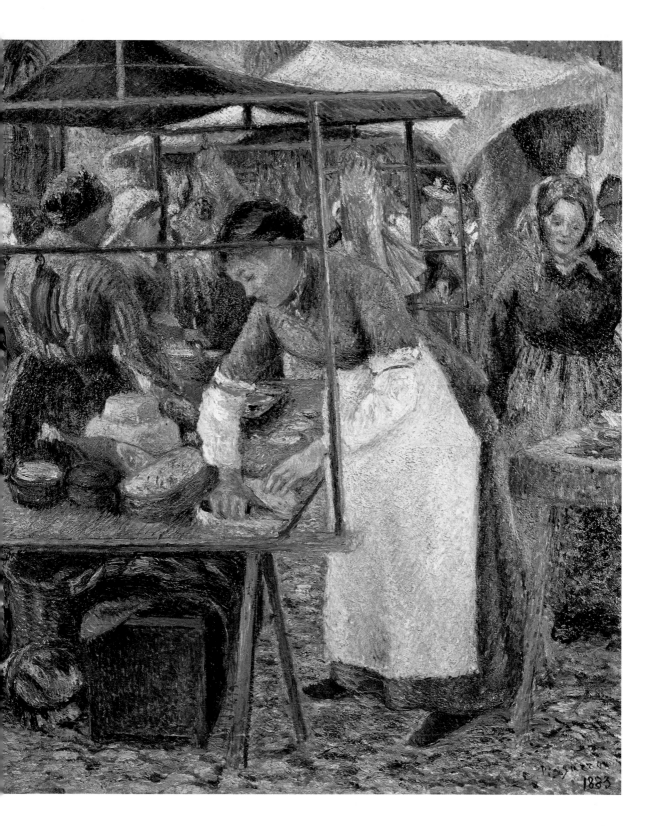

Lise with parasol

Oil on canvas, 182 x 113 cm
Essen, Museum Folkwang

* 1841 in Limoges
† 1919 in Cagnes

Already at the outset of his career, Pierre-Auguste Renoir was, to a greater extent than Pissarro, Sisley or Monet, a figure painter rather than a landscape painter. The painting *Lise with Parasol* also focuses on a person.

In the 1870s, what was demanded of contemporary modern art was this: "Let us take our leave of the stylized human body that is treated like a vase. What we need is the characteristic, the modern human being in his or her clothes, in the midst of his or her social environment, at home or in the street." (Edmond Duranty)

Statements like these accorded perfectly with the ideas of Renoir and Frédéric Bazille. Renoir had, to start with, sought his motifs in subjects from the world of the Greek and Roman gods, for example in *Diana* (1867, Washington, The National Gallery of Art), but in the late 1860s turned increasingly to themes taken from contemporary life. And he sought to capture the effect of light and shade on colours, in particular on black and white. His interest in the art of earlier centuries may have played a role here.

The Impressionists were not the first artists to confront questions like these. Leonardo da Vinci, the great protagonist of the Italian Renaissance, wrote: "If you see a woman dressed in white in the midst of a landscape, that side which sees the sun is so bright that it will dazzle the eyes like the sun; and the side which is towards the air, luminous through being interwoven with the sun's rays and penetrated by them, since the air itself is blue, that side of the woman seen by the air will tend to the blue. If the surface of the ground nearby is a meadow and if she is between the meadow and the sun itself, you will see the parts of those folds which can be seen by the meadow tinge by the reflected rays with the colour of the meadow."

This sounds as if Leonardo were describing an Impressionis picture, for example *Lise with Parasol*. Lise's white dress seems a most unpleasantly dazzling in the sun. In the shade, Renoir added blue tinge. The same technique was followed by Monet in his snows cape *The Magpie* (Paris, Musée d'Orsa; ill. below), which was execut ed only two years later.

Both artists are concerned with the effect of the bright sunligh on white, and with the change that white undergoes in the shade. I order to intensify the radiance of the white even further, Renoir an Monet use strong chiaroscuro contrasts. The oft-repeated assertio that the Impressionist artists used no black, because there is no pur black in nature, is therefore false. Renoir gives Lise's dress a broa black bow and Monet places a mostly black bird, the magpie, on fence in the middle of a white snowfield.

Renoir, who went as far as to regard black as the "queen o colours," was however one of the few Impressionists – Berthe Moriso was another – to use pure ivory black. Monet and many other artist liked to mix the same pigment with other colours, for example green o blue. Thus the seemingly black railway engines in Monet's painting *L Pont de l'Europe* by the Gare Saint-Lazare (ill. p. 55) in a mixture o ivory black and blue.

Claude Monet, The Magpie, 1869

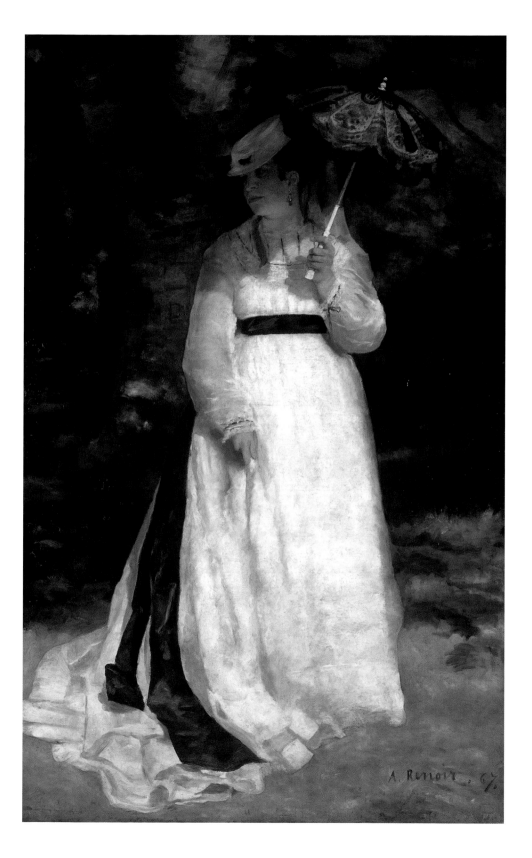

Boats on the seine (The seine near Asnières)

Oil on canvas, 71 x 92 cm
London, The National Gallery

Renoir had as a young man been apprenticed as a porcelain painter, and was consequently highly familiar with the use of soft round brushes and applications of transparent paint. He then moved on to painting fans, on to which, for example, he copied the early-18th-century motif of *The Embarkation for Cythera* by Antoine Watteau. Then he accepted a number of commissions to decorate Parisian cafés. "I chose as my motif Venus rising from the waters. I can assure you that I was not sparing with my Veronese green or cobalt blue … I decorated some 20 cafés in Paris … Even today I would like to paint decorations like Boucher, transform whole walls into an Olympia …"

And indeed, with the best will in the world, it is impossible to overlook the decorative aspect in Renoir's pictures: sunny, luminous harmonies full of a lust for life, one long "Sunday."

Renoir does not appear to have been sparing with paints in *Boats on the Seine* either. His palette however consisted of just seven intensive colour pigments: cobalt blue, viridian (a dark green with a large blue component), chrome yellow, lemon yellow, chrome orange, vermilion, and a transparent red gloss. White was also abundantly used for the numerous dabs all over the picture. Black is however absent from this particular painting, as are the earth colours such as brown, sienna, ochre and the like.

Boats on the Seine is one of a group of related motifs to which Renoir devoted himself in Chatou on the Seine in 1879/80. Compositionally, the picture is similar to Monet's *The Bridge at Argenteuil*, which had been executed five years earlier. Both artists placed a bridge on the right-hand side of the picture, in both cases with a train passing over it, against the background of a river-bank with a house. But while Monet depicted a specific place, Renoir was concerned with the general depiction of a Sunday atmosphere: two elegant young ladies are having themselves boated down the Seine on a bright Sunday. Renoir structured the brilliant "mosaic" of the water using a number of different painting techniques. The rapid application of liquid paint on a wet surface alternates with more viscous, almost dry paint on a dry surface. At the point where the boat intersects with the surface of the water, we see little white specks of foam. They consist of dabs of thick paint, loosely applied to the canvas. Seemingly random structures like these demonstrate the specific technique of Impressionism.

The contrast of the complementary colours which Renoir chose for *Boats on the Seine* is what determines the whole picture. The combination of orange and blue follows Eugène Chevreul's colour theory dating from 1839, according to which these colours, when juxtaposed, intensify each other. In Chevreul's colour circle, orange and blue are diametrically opposite, precisely those colours, in other words, which Renoir chose here. By exploiting the contrasting effects and using exclusively pure, unmixed colours, the artist obtained a unique, radiant light.

"For me a picture must always be something lovable, pleasurable and pretty, yes, something pretty. There are enough unpleasant things in the world; we do not have to produce any more."

Pierre-Auguste Renoir

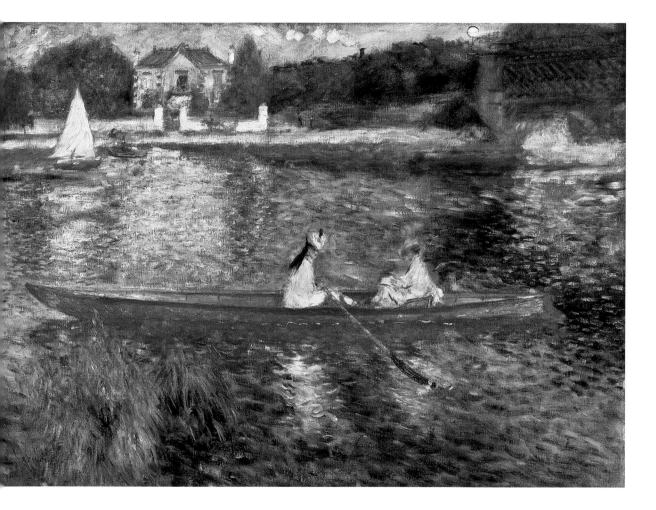

Aetas Aurea (The Golden Age)

Wax over plaster, height 41.91 cm
San Francisco, Fine Arts Museums of San Francisco; Legion of Honor and de Young Museums

* 1858 in Turin
† 1928 in Milan

Among late-19th-century sculptors, Medardo Rosso is one of the least known, but also one of the most interesting. His aesthetic concentrated on light and the dissolution of matter, in contrast to conventional sculptural works, where volume and weight are what count. It is this attempt to integrate light into the way sculpture comes across which create the association between him and sculpture.

Rosso's works are, in addition, often meant, like a relief, to be seen from only one side. They allow only one view, one aspect. It is said that when Degas saw Rosso's photograph of his [Rosso's] work *Impressione d'omnibus,* he thought he was looking at a photograph not of a sculpture, but of a painting.

The sculpture *Impressione d'omnibus,* which we now know only from the photograph, represented three people on the seat of a bus. Rosso's procedure was similar to that used by Degas in his painting *Absinthe* (ill. p. 41), which predates *Aetas Aurea (The Golden Age)* by ten years. Both artists had models pose at their [the artists'] direction, and in this way reconstructed a detail of their everyday city surroundings.

Rosso chose an experimental treatment of the material. In the 19th century, the production of the finished bronze sculpture from the wax or clay model was traditionally left to specialist craftsmen.

Rosso by contrast intervened in every stage of the process. What hitherto had been seen merely as an intermediate stage on the way to a completed bronze sculpture, Rosso presented as a finished work of art. We can see a comparable process in the work of the Impressionist painters, who saw a finished painting in what for the conservative art-world was merely a sketch. In his boundless zest for experimentation, Rosso more than once created a number of versions of the same theme.

The sculpture *Aetas Aurea* is an example of these peculiarities in Medardo Rosso's works, and demonstrates the possibilities of Impressionist sculpture. It is a relief-like work, with the reverse left untreated, executed in wax over plaster. The wax model become the final state, not functioning just as a mere intermediate stage on the way to a bronze cast. The fragmentary form, with the seemingly broken-off outer edges and the hollow reverse, is typical of Rosso's intentions.

The sculpture consists of fragments of the human body: the head and arm of a mother and the head of a child. In spite of this fragmentation, any beholder can quickly recognize that the mother is inclining comfortingly over the screaming child and tenderly caressing its face with her hand. Thus she holds the child pressed closely to herself, cheek to cheek. The boundaries between the two figures disappear in the structure that connect them.

The Concierge, 1883

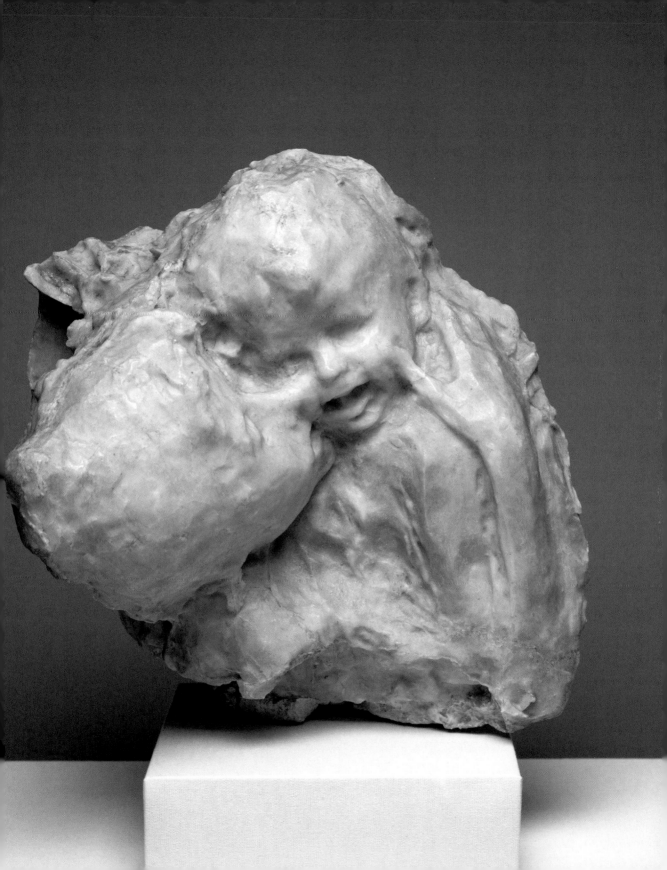

In the Jardin du Luxembourg

Oil on canvas, 65.7 x 92.4 cm
Philadelphia Museum of Art, Pennsylvania

* 1856 in Florence
† 1925 in London

The Jardin du Luxembourg in the Quartier Latin was frequented by many artists who, like Sargent, had studios nearby. Sargent chose the large pond in the centre of the park as his central motif. A sketchy depiction, in which the dome of the Panthéon can be seen in the background, he dedicated to a friend. The version illustrated here he exhibited at the National Academy of Design in New York in 1879.

As the largest inner-city open space on the left bank of the Seine, the park fulfilled important social functions. Having a stroll in this classless atmosphere accorded with the Parisian attitude to life at the time.

Sargent had come to Paris in 1874 and enrolled as a student at the École des Beaux-Arts. In the early 1880s he had close contacts with the Impressionist artists, Monet in particular, but did not take part in their exhibitions, showing his works until 1888 at the official Salon instead. Monet for his part had also taken up the "park" theme in 1878. His two pictures painted in the Parc Monceau reflect similar impressions.

In the painting *In the Jardin du Luxembourg* the artist focused his attention in particular on the light. Sargent's solution here to the play of light and shade, which occupied the Impressionists so greatly, is to depict the place at dusk, in shimmering moonlight. The whole scene seems bathed in a violet twilight which blurs the differences in light quality. The tender grey-violet tones are broken by individual red dabs of colour: in the woman's fan, in the flower-beds, and in the lights on the balustrade. The strong red is all the more striking as these dabs of colour are for the most part placed against their complementary colour, green.

Sargent may have had the famous nocturnal studies by Johan Barthold Jongkind in mind when he painted this twilight scene in the park. Jongkind was seen as a role-model by many Impressionists, and Monet, who had been his pupil, said: "From then on Jongkind was my real master. I owe the definitive training of my eye to him." Jongkind's painting *Notre-Dame in Paris by Moonlight* (Reims, Musée des Beaux-Arts) could have provided an important stimulus for Sargent to paint his own moonlight park picture.

Sargent's canvas *In the Jardin du Luxembourg* is not a narrative, but depicts a moment seemingly chosen at random: a couple are strolling past, a man by the pond is reading a newspaper, the moon is reflected in the silvery surface of the water. Sargent attached particular importance to the elegant clothing of the couple as they stroll across the empty foreground. "Modernity and fashion were closer to each other, and the modern artists, who included the Impressionists, had a fashionable public, which was not the same as economic success." (Christoph Becker)

The same year Sargent portrayed *Madame Édouard Pailleron* in the garden of her house. Mme. Pailleron is wearing a very elegant black-and-white afternoon dress and gathering the skirt with the same zigzag movement as the young lady in the park. With portraits like that of the social elite, John Singer Sargent became extremely successful.

"I do not judge, I only chronicle."

John Singer Sargent

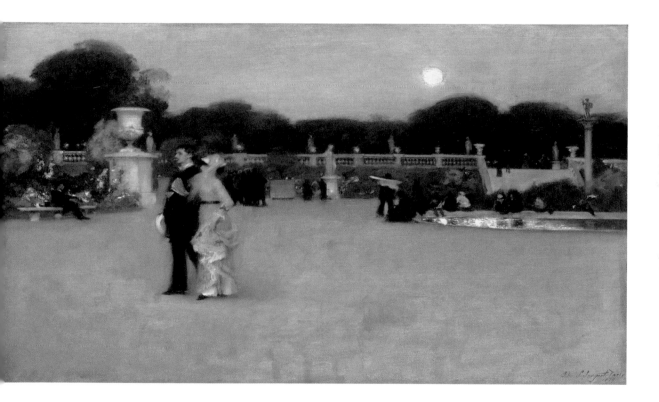

The Hay Harvest

Oil on canvas, 137 x 149 cm
St. Moritz, Segantini-Museum

* 1850 in Arco
† 1899 in Pontresina

"Then I saw how this ray of light got bigger and bigger, until it finally took on human form, the form of a woman. But just as the figure had formed, just as it seemed almost alive, and comprehensible to the eye, it dissolved once more, disintegrating into luminous pink spots. But I continued to gaze fixedly at this place, and she reappeared, remaining fluid but recognizable in her diaphanous, luminous form … The beautiful divine figure surrounded itself with a silvery pool of light, which spread out and thrust aside the dark shadow of the cloud."

Segantini's arresting description of a vision of divine celestial manifestations points to the semantic content of his motifs. Light and shade, working woman and cloudy sky are no longer a spontaneous expression, a random detail of reality, but become metaphors of divinity and threat, of existence and salvation.

Segantini developed his Symbolist art in the years following 1886 with motifs from the Alps, to which he applied the divisionist painting technique. His early works largely comprise realistic genre scenes, which point to Millet and Daubigny as role models. The painters of the Barbizon School, among them Millet in particular, had become portrayers of the rustic world "par excellence." The hard work of the rural population is shown in Daubigny's *The Haystack* (ill. p. 15) and in Segantini's *The Hay Harvest* to be a constantly repeating, endless process. Erecting the haystack will be followed in the none-too-distant future by taking it down again. Raking the hay together and loading it has, as its sole purpose, distributing it once more to the cattle in winter. Daubigny depicts this as an anonymous process with small figures in the landscape, while Segantini places one figure, and the associated feelings, in the foreground. She arouses pity or else melancholy. Segantini drew on his daily dealings with peasants and shepherds, and generalized their individual experiences into representations of collective destiny. This emotional, "archaic" quality led to the artist being misused by the Fascist blood-and-soil ideology, his work being appropriated for a regressive "homeland" art. Also the later romantic-sentimental exploitation of Segantini's pictures for tourist purposes ignored the complex content of his paintings.

Segantini began *The Hay Harvest* as a narrow landscape format in Savognin in about 1889. In this early version the artist had painted a flat, even horizon, the torso of the peasant woman projecting above it, just as the smaller figures of the peasants and the haystack interrupted the line of the horizon. In 1898 Segantini added a piece of canvas to the top edge, so that an approximately square format resulted. He added the mountain range and the sky in its present form thus creating the symbolic meaning: the radiant divine light breaks up the dark of the clouds, but in contrast there is human life on earth which cannot influence fate, but only submit to it, as the peasant woman has to submit to the hay harvest. For Segantini as for the Impressionists, light had top priority, albeit with a quite different interpretation. The painting technique of closely placed short strokes which constitute a transparent yet powerful colourfulness, is something he adopted from the Neo-impressionist movement.

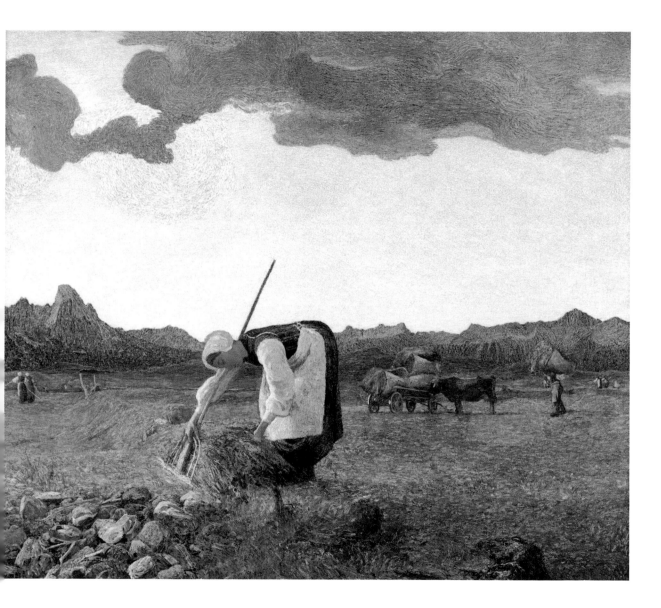

The Bathers at Asnières

Oil on canvas, 201 x 300 cm
London, The National Gallery

* 1859 in Paris
† 1891 in Paris

With *The Bathers* Georges Seurat completed his first example of the synthetic style of Neo-impressionism. He displayed this eye-catching painting at the Salon des Indépendants in 1884, after it had been rejected by the official Salon. In 1886 the French art-dealer Durand-Ruel, who worked closely with the Impressionist artists, took *The Bathers at Asnières* to an exhibition in New York. It was the most controversial of all the exhibits.

Seurat was also controversial among his fellow-artists. His and Paul Signac's participation in the eighth Impressionist exhibition triggered a heated debate. Finally, Pissarro succeeded in achieving a decision in favour of the two young artists. In protest, Monet, Renoir, Sisley and Caillebotte withdrew, and the Impressionist group broke up. A series of articles in the press fêted Seurat and Signac as representatives of a new style which had made Impressionism obsolete. The two were then given the still-current epithet of Neo-impressionists.

Seurat addressed his total energy to the intensity of his artistic work. His œuvre in the space of about twelve years comprised just four large paintings, alongside a number of smaller pictures, draughts and oil-sketches.

His working method differed substantially from that of the Impressionists. He painted a great deal in the studio and not in the open air; and in a fashion not spontaneous and immediate, but systematic and considered.

For *The Bathers at Asnières* a number of individual studies were done on the island of Grande Jatte; these grew together to create the total composition. The study *Horses by the River* (London,

The Courtauld Institute Galleries) makes it clear how Seurat worked. He followed Corot's maxim of first indicating the strongest colours, and then proceeding systematically to the palest. Accordingly, Seurat first marked the darkest shades, and then the lightest. The brown and white horses, with which he experimented in this way for a long time, ultimately failed to make an appearance on the finished painting *The Bathers at Asnières.*

The execution of the painting then followed exclusively in the studio, which, given the size of the canvas, was virtually inevitable. The work depicts people on the bank of the river opposite the island of the Grande Jatte. In the background can be seen a factory building and a bridge. A ferry is carrying passengers to the island. Although Seurat conceded the highest priority to the Impressionist criteria of colour and light, he came to a completely different result. Seurat's goal was not the fleeting impression, but the configuration of many moments. Addition was what determined the motif. Not the transitory, but the enduring – that was what he wanted to capture on canvas. Accordingly, Seurat's style has been termed "synthetic." His return to the traditional, academic working method was accompanied by a scientific examination of colour. In the following years, Seurat developed, on the basis of physics, optics and geometry, the Pointillist colour theory, which Camille Pissarro also followed for a time.

Study: Horses by the River, 1883

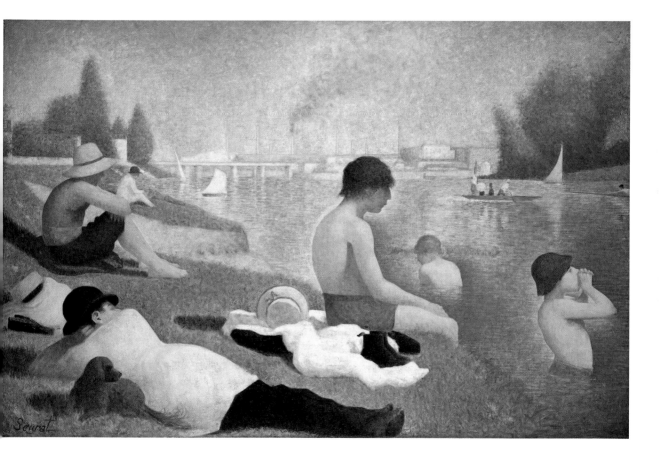

тhe Gallery of the old Bedford

Oil on canvas, 76.2 x 60.4 cm
Liverpool, National Museum

*** 1860 in Munich**
† 1942 in Bathampton

Walter Richard Sickert had a particular association with the world of the theatre, having first worked as an actor. Maybe that was why the audience was more important to him than what was happening on stage, as in the painting *The Gallery of the Old Bedford.*

Sickert found his preferred motifs in the world of London's theatres and music halls, in particular the Bedford Theatre in Camden Town provided him with a motif a number of times. In the painting *The Gallery of the Old Bedford* he made the audience the compositional focus of the picture for the first time, a habit which, with few exceptions, was to last into the 1920s. In *The Gallery of the Old Bedford* he also concentrates on the audience in the gallery, rather than the classier types in the stalls.

The painting was probably conceived as a pair to the same artist's *Little Dot Hetherington at the Bedford Music Hall,* in which the little-known singer of that name is depicted on stage. In a performance in November 1888 she sang the well-known song "The boy I love is up in the Gallery," at the same time pointing in the relevant direction, as Sickert depicted. Since this time, Sickert had made drawings of the interior furnishings of this old-fashioned building, and captured various other performances on canvas. *The Gallery of the Old Bedford* is one of a whole series of depictions of the gallery executed in the 1890s, differing principally in coloration and lighting.

Here, we see a pale reddish shimmer on the gallery, reflecting the stage lighting. All the faces of the exclusively male audience are turned towards the stage. In connection with the painting *Little Dot Hetherington at the Bedford Music Hall* it is clear that each of the men is dreaming – in line with the words of the song – that he is "the boy I love." The painting itself is like a dream in red and gold, and is indeed only half "real," the other half being a reflection in the mirror.

During the 1890s Sickert was one of the leading artists of the English avant-garde. He was a member of the New English Art Club, which exhibited and propagated modern art in Britain. As a pupil of James McNeill Whistler and a friend of Edgar Degas, with whom he shared his passion for the theatre, Walter Richard Sickert was a leading exponent of London Impressionism.

Sickert had got to know Degas in 1883, when he took one of Whistler's paintings to the exhibition at the Paris Salon. Whistler, who lived in England, had written letters of introduction for him, including one to Degas. Thus it was that Sickert quickly made contact with the Impressionist painters, being strongly influenced by Degas in particular. In 1885 Sickert, together with Degas and other artists, spent a few weeks in Dieppe and painted under his direction. During their joint sojourn, Degas made a small pastel drawing: one of the *Six Friends of the Artist* (1885, Providence, R. I., Museum of Art, Rhode Island School of Design) is Walter Richard Sickert. Dieppe was an important place for Sickert, one to which he returned time and again, especially in summer.

> **"on a series of apparently tiresome, flat sittings seeming to lead nowhere – one day something happens, the touches seem to 'take', the deaf canvas listens, your words flow and you have done something."**
> **Walter Richard Sickert**

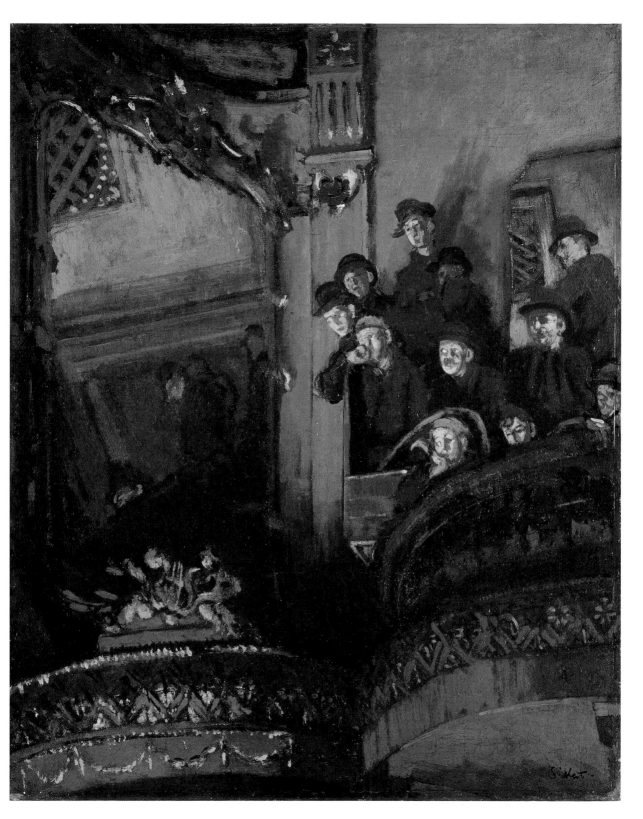

capo di Noli, near Genoa

Oil on canvas, 91.5 x 73 cm
Cologne, Wallraf-Richartz-Museum, Fondation Corboud

* 1863 in Paris
† 1935 in Paris

"I began Capo di Noli, in which I wanted to obtain extreme polychromy. In order to practise, I used my sample of silk dyes, which are so intense and luminous. I shall transfer them one after the other on to my canvas. I do not want one single centimetre of matt colour to remain and I want to transform every bit of the painting to something extreme. If it gets a little garish, it can always be toned down."

As far as we know, Signac did not tone down the colours, but left them as they were. The painting *Capo di Noli* was seen as the climax of Signac's intoxication with colour.

The Mediterranean surroundings doubtless contributed to the use of such strong colours. Capo di Noli is on the Italian Riviera, which Signac liked to visit from his base in Saint-Tropez, where he lived from 1892 to 1900, exploring the surroundings in his yacht "Olympia." He also discovered a new colour dimension in nature, which was reflected in his work of this period. The white and red cliffs, the pale violet horizon, the blue shadows with patches of golden sunlight – all bear witness to Signac's attempt to elevate colour to heights of intensity.

After Seurat's death in 1891, which affected him greatly, Signac increasingly sought artistic paths of his own. His statements at this time constantly centred on concepts such as freedom and harmony. "Let us liberate ourselves! Our goal must be to create beautiful harmonies." By this he meant getting away from the idea of painting from nature, such as he had done until then. It now seemed to him a waste of time to produce an image of nature as precise and faithful as pos-

sible. In the years around the turn of the century, he crystallized a personal approach out of Seurat's scientific theory of colours.

In contrast to his earlier works, Signac no longer followed the colour theory determined by the use of two contrasting colours. *Capo di Noli* displays a free and harmonious juxtaposition of a whole variety of colour values, which Signac applied in vertical and horizontal brushstrokes. The cliffs on the left-hand edge of the picture and the vegetation on the right-hand side are reproduced with vertical strokes in accordance with their structure. The path, and the calm, motionless sea have been executed in horizontal brush movements. The sky is painted on the horizon with little dots, and towards the foreground of the picture with diagonal strokes that cross each other. With this structural use of the brush, Signac supports the impressively harmonious composition of the painting. It seems to be an "ideal" view of a timeless, sunny landscape.

In 1894 Signac wrote: "A few years ago, I sought with great effort to prove to others, using scientific experiments, that these blue tones, these yellow colours and these variations on green all existed in nature. Now I am content to say: I paint in this way because this technique seems to me to be the most appropriate way to obtain the most harmonious, the most light-filled and the most colourfully luminous result … and because I like it."

> **"the anarchist painter is not the one who will create anarchist pictures, but the one who will fight with all his individuality against official conventions."**
> **Paul Signac**

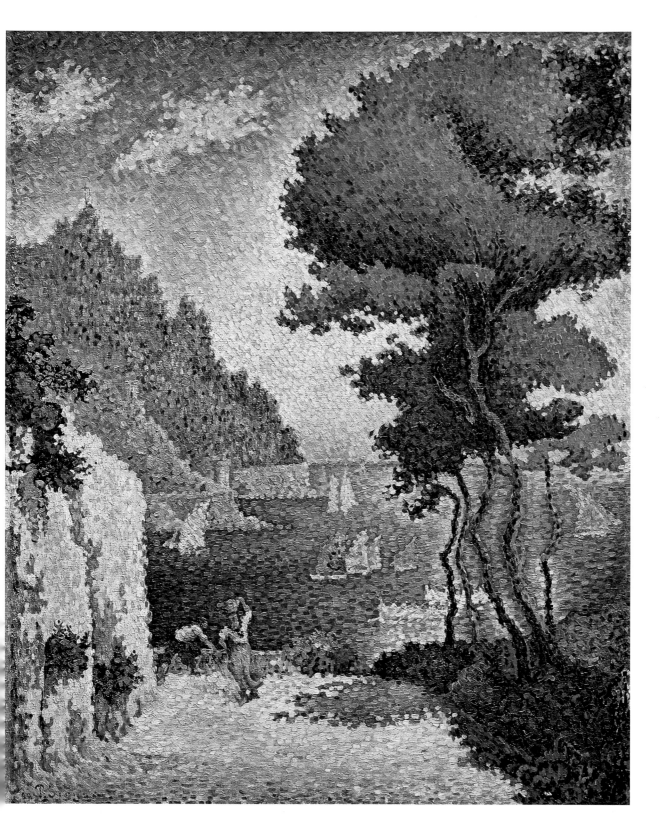

тhe papal palace in Avignon

Oil on canvas, 73.5 x 92.5 cm
Paris, Musée d'Orsay

In the first years of the 20th century Paul Signac turned time and again to buildings on the water's edge. He produced views of Notre-Dame-de-la-Garde in Marseilles, the church of Santa Maria della Salute on the Grand Canal in Venice, the lighthouse in Biarritz, the town of La Rochelle and *St. Tropez Harbour* (ill. below), all viewed from across the water. Like Daubigny and Monet, he probably used a boat to find the relevant motifs. This also provided him with an opportunity, after all, to depict sophisticated reflections of the colours on the water.

In the 1880s Signac had, along with his friend Armand Guillaumin, painted landscapes and Parisian cityscapes – visibly under the influence of the characteristics of Impressionist art.

Surprisingly, Signac did not undergo the usual training at the École des Beaux-Arts. Especially for the older generation of Impressionists, a formal training at the academy was after all still obligatory. Instead, Signac was self-taught. He adopted Impressionism by looking at its works, and learned chiefly from his close friend Georges Seurat, whose Pointillism had a decisive influence on his style.

At the start of the 20th century, Claude Monet struck out along a similar path to Signac: both worked with simplified forms and fasci-nating, dominating colours. Monet's *Houses of Parliament, Stormy Sky* even uses the same reddish-violet atmosphere as Signac in his *The Papal Palace in Avignon.*

Paul Signac captured the palace in Avignon in two versions. The painting illustrated here dates from 1900 and depicts the monumental architecture in the morning light. For the second painting, Signac chose the same view at sunset.

The palace was built in the 14th century, when a number of popes resided in Avignon. In order to bestow prestige and dignity on the papal residence, a vast Gothic fortress with a city wall was erected, and the neighbouring cathedral of Notre-Dame-des-Doms extended. The bridge over the Rhône, the Pont d'Avignon made famous by the children's song, was partly destroyed in the 17th century. Signac depicted the still extant surviving arches on the left-hand side of the picture. Like Alfred Sisley in his painting *The Watering Place at Marly-le-Roi* (ill. p. 87) Signac did not portray this impressive architectural ensemble for its historical significance, but used it as a fantastically beautiful motif for the play of colours at sunrise.

Here, Paul Signac was following his maxim: "Simplification of the elements leads you to more colour." He reduced the building to its silhouette and a few features of the internal structure. The edifice, with the adjacent church, the riverbank vegetation and the bridge are still recognizable. Water and sky flow into one another. The palace, radiant in the morning sunlight, rises majestically, like some timeless vision, from the riverbank vegetation still submerged in darkness.

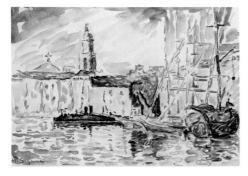

St. Tropez Harbour, c. 1905

**"тhe golden age has not passed;
it lies in the future."**

Paul Signac

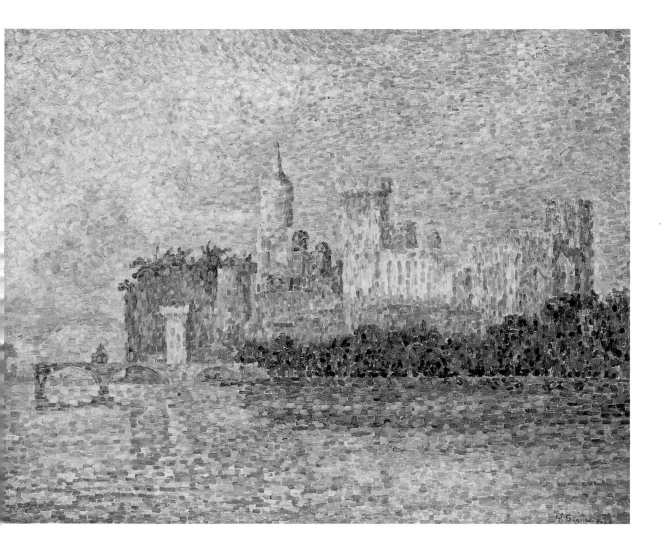

The watering place at marly-le-roi

Oil on canvas, 49.5 x 65.4 cm
London, The National Gallery

* 1839 in Paris
† 1899 in Moret-sur-Loing

"I always begin a picture with the sky," wrote Alfred Sisley, who painted almost nothing but land-scapes. "Its planes give depth (for the sky has planes as well as solid ground) and the shapes of the clouds give movement to a picture. What is more beautiful indeed than the summer sky, with its wispy clouds idly floating across the blue? What movement and grace! Don't you agree? They are like waves on the sea; one is uplifted and carried away. But there is another aspect – the evening sky. Clouds grow thin, like furrowed fields, like eddies of water frozen in the air, and then they gradually fade away in the light of the setting sun. Solemnity and melancholy – a sad moment of departure which I find especially moving."

In his painting *The Watering Place at Marly-le-Roi* Alfred Sisley concentrated on the winter sky, in which a milky sun is trying to shine through the layer of cloud. The reddish beige of the canvas primer is visible through the thin layer of paint in many parts of the picture and in large areas of the sky is totally uncovered. The shade of the canvas primer, which was originally lighter, dominates the whole picture. It is very probably a commercial primer, not applied by Sisley himself.

He used the shade of the ready-primed canvas for the leaden light of a winter's afternoon that weighs down on the painting. The thin layer of paint and the narrow range of colours employed are typical of Sisley's work at this period. *The Watering Place at Marly-le-Roi* uses just five colours plus black and white. The hasty brush-strokes point to the picture's having been painted quickly. It was done in one sitting in the open air, only a few dabs of paint being added later when the painting was dry. This picture is, then, one of the few that reproduces an immediate, spontaneous impression in accordance with the Impressionist ideal.

The "Watering-place," which occupies the entire foreground of the picture, is on the edge of the grounds of the former château de Marly, built by Louis XIV in the 17th century and destroyed in the French Revolution. Sisley lived with his family from 1874 to 1877 in Marly-le-Roi, struggling with major financial difficulties.

Sisley painted the motif of the "Watering-place" in Marly-le-Roi and other remains of the royal fountains about a dozen times in the winter of 1876/77. At the same time, Gustave Caillebotte painted a view of the "Pumping Station in Marly."

Sisley used the long Baroque visual axis, which leads across the pool and along the street into the countryside as the composition line of his painting. Like Claude Monet in his painting *The Artist's Garden in Vétheuil* (ill. p. 57), Sisley used this central line in order to create depth.

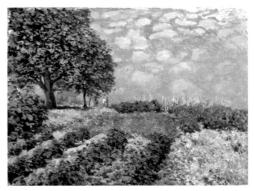

The Market Gardens, 1874

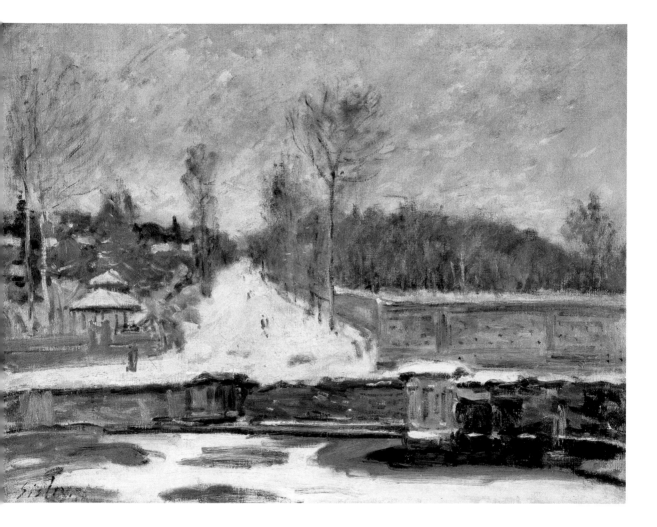

The Path to the old Ferry

Oil on canvas, 50 x 65 cm
London, The National Gallery

The Path to the Old Ferry is another of Sisley's landscapes in which the depiction of water is central. As in his early work *Autumn: On the Banks of the Seine near Bougival* (ill. p. 20), Sisley painted a ferry across the river, a village on the riverbank, a path running down to the bank, and little human figures as accessories.

Not only are the colours stronger, Sisley's brush-strokes too have become more powerful, and the application of paint is no longer quite so transparent as in the 1870s. As his composition line, Sisley once again uses a path, which here runs inwards from the bottom left-hand corner and creates the necessary depth. At the same time, the artist directs the eye of the beholder to the rectangular red patch in the centre of the picture, which is on the opposite riverbank. This red patch in the midst of green surroundings is particularly striking, as Sisley here makes use of the complementary colour pair of red and green. Immediately below this red roof, for that is what it is, we see a

group of people standing waiting on the near bank. Thus the beholder anticipates visually the movement that the waiting people still have ahead of them, namely being ferried to the far bank. In this clever fashion, Sisley succeeds in integrating the beholder into the picture and above all into the movement.

The picture is given, in addition, expected tension by the crossing of two divergent directions of movement: The river, which follows a calm horizontal line from right to left, is painted with horizontal brush-strokes. This is crossed by the ferry and the gaze of the beholder into the depth of the landscape. The resistance of the water to the ferry becomes positively palpable.

Sisley himself wrote of movement in the landscape: "Apart from the motif itself, the chief interest in landscape painting is in life and movement. The animation of the canvas is one of the hardest problems in painting. Everything must contribute: the form, the colour, the execution ... The artist's impression is the life-giving factor, and only this impression can free that of the spectator. Though the artist must remain master of his craft, the surface, at times raised to the highest pitch of loveliness, should transmit to the beholder the sensation which possessed the artist."

Sisley thought the artist should leave out superfluous detail, and that thus "the spectator should be led along the road that the artist indicates to him, and from the first be made to notice what the artist has felt." In the painting *The Path to the Old Ferry* and in many other of his works, the fascinating thing is the crossing of the water, be it on the ferry, over the bridge or with the eye.

"Every picture shows a spot with which the artist has fallen in love ..." (Sisley). Sisley felt finding this particular spot to be extremely stimulating when looking at a work of art.

Regatta in Molesey near Hampton Court, 1874

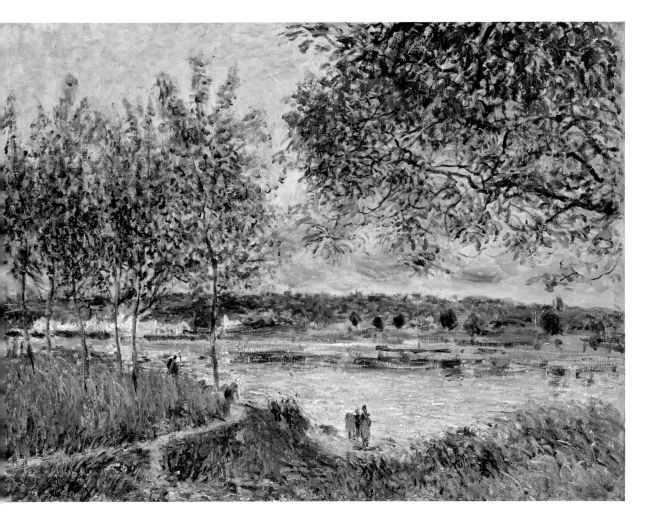

parade

Oil on canvas, 48.4 x 57.5 cm
Hannover, Niedersächsisches Landesmuseum

* 1868 in Landshut
† 1932 in Neukastel

Max Slevogt painted the military parade through the Brandenburg Gate on 17 June 1913, the 25th anniversary of Kaiser Wilhelm II's accession to the Prussian and German thrones. Slevogt watched the parade from the upper storey of a building on the south side of the street.

There are two versions of the event. The painting *Parade* illustrated here depicts the parade in the morning. The second version, with the same format, was painted in the afternoon from a higher balcony. While the morning picture gives us a view of the parade itself, the afternoon painting quickly passes over the crowded street to give us a look at the beflagged roofscape beyond. The large black, white and red tricolour of the German Empire hanging from a crown-topped staff on the neighbouring building finds itself competing for our attention with an advertisement for the Passage Theater situated in the building.

Slevogt's morning impression chooses as its subject the parade itself as it moves from left to right across the picture. The marching soldiers, whose dynamics are underscored by the diagonal course of the street, are merely sketched with rapid brush-strokes. Only the black, white and red of the Prussian flag and the blue coats of the soldiers give us any indication that this is a Prussian military parade. Slevogt concentrates on the staccato of the marching soldiers and the shadows, which lie across the direction of march. These short strokes determine the whole structure of the picture and continue in the background in the slower rhythm of the vertical tree-trunks and flagpoles.

It is probably no coincidence that the brushstrokes that charac terize the marching soldiers on the right recall musical notes on score. Slevogt's concurrent work on illustrations to Mozart's *Magic Flute* and his marginal drawings for the score of the opera are clearly reflected here. Slevogt admired Mozart's score: "No visual artist can wield his pen more animatedly, more sensuously, more wittily. One can with the eye alone grasp the sound, the spirit of the work … Just a Mozart forms the heads of the individual notes differently, sensitively stretching the connecting strokes, hastily placing the bar-lines … the thousand ways that he has of crossing something out, the indescrib able grace which lies over every page as a whole item, all this can only amaze anyone who has any sense of the line, of its expressive value."

Slevogt in his turn transformed – no less hastily and gracefully – the "expressive value of the line" of marching soldiers into notes Rhythm and music are permanently integrated into the depiction Slevogt's method of depiction differs considerably from the parade that the American Impressionist Frederick Childe Hassam painted Hassam, who chose as motifs the Bastille Day parade of 14 July 1916 in Paris and the parade down Fifth Avenue in New York on Allies Day 17 May 1917, drew the flags very strongly into the foreground Slevogt's art collection included Manet's *Rue Mosnier with Flags,* dating from 1878 (Los Angeles, J. Paul Getty Museum). Maybe this picture encouraged him to paint his own motif.

It was not Slevogt's intention to glorify the military power of the Reich. A year before the outbreak of the Great War, the Kaiser was notorious in Europe as a sabre-rattler who only too willingly underlined his power with shows of military strength. Slevogt by contrast was concerned, in the spirit of Impressionism, with presenting the cheerful mood and the bright atmosphere. The transience of the moment is expressed in the intoxicating sound of the music as it passes by.

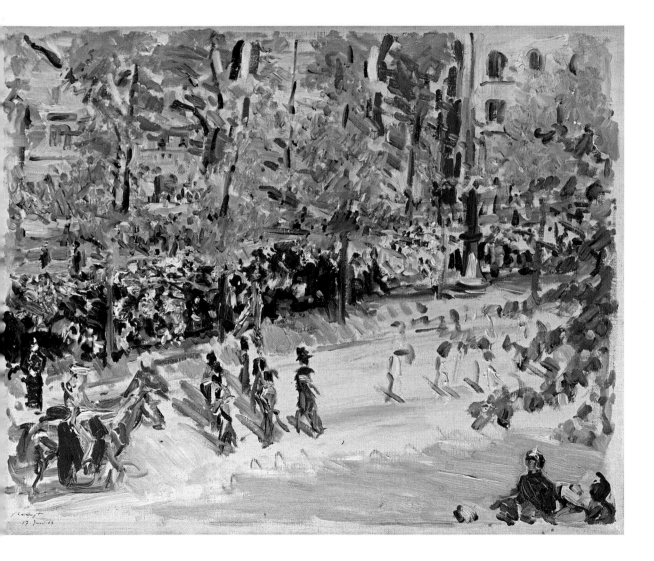

THE GARDEN PATH

Oil on canvas, 61 x 76 cm
Bremen, Kunsthalle Bremen

* 1848 in Wolkenburg
† 1911 in Munich

"Today I did something really extraordinary, such as I have perhaps never done before. Working in the open air in fine, airy shades, that seems to be my field. It was also very easy for me, and in addition it is infinitely more interesting to paint from nature like this than in the boring light of the studio," wrote Fritz von Uhde in September 1882, while he was staying in Holland. His time in Paris as a pupil of the Hungarian painter Mihály Munkacsy had come to an end, and he returned to Munich. Already from Paris Uhde had written that he had "got a technique which is simple and perfectly correct, and at the same time colorist to a high degree." Open-air painting led Uhde first and foremost to realistic art, in other words to a depiction of reality which was not only as faithful as possible but included figures like Dutch fishermen's children that had previously not been considered artworthy.

When in 1883 Fritz von Uhde together with Max Liebermann was represented at the International Art Exhibition in Munich, one art-critic refused to discuss the two artists in the German section, since "with their latest endeavours they belonged among the French." The young German Reich was occupied with a search for an identity of its own, and this led to a sometimes vehement rejection of everything that had to do with French art and French culture. This tendency delayed the success of Impressionism in Germany.

It was only after the turn of the century that Uhde's Impressionist-like style found any recognition. One picture which did was the painting *The Garden Path,* which was acquired in 1904 by the then director of the Kunsthalle in Bremen, Gustav Pauli. It depicts vo Uhde's three almost grown-up daughters, to whom he was very clos since their mother had died a few days after the birth of the younges

Fritz von Uhde had taken on the then unusual role of a lon father. This makes it easy to understand why time and again he chos to paint his children, whose world was so familiar to him, be it in th garden, at their lessons or reading. With motifs like these, most o which date from after 1900, he broke increasingly away from Realisr and turned to Impressionism. At the same time the garden of h country house in Percha, a favourite place of his daughters, became refuge, rather like the garden of Liebermann's Wannsee villa.

The Garden Path depicts the corner of a house at the botton right-hand edge of the picture, where two paths meet and lead to th garden on the left. The three girls are going along the path, followe by their dog, passing the trained fruit-trees in the background. Th rectangular grid which provides a frame for the fruit-trees forms an in teresting contrast to the luxuriant greenish-brown wilderness. Brigh patches of light play on the girls' clothes and on the path. These shim mering patches are reproduced with filmy bright brush-strokes, loose ly distributed on the canvas. The light, filtered through the gree canopy of foliage, is Uhde's central concern in this painting.

The garden path was the subject of a total of nine work between 1903 and 1908, seven of them oils and one a watercolou But unlike Monet's haystack series, Uhde was not concerned with th changing light in the course of a day, but of the changes that occurre over the years. He was to return to the "fine, airy" shades once more a the end of his career.

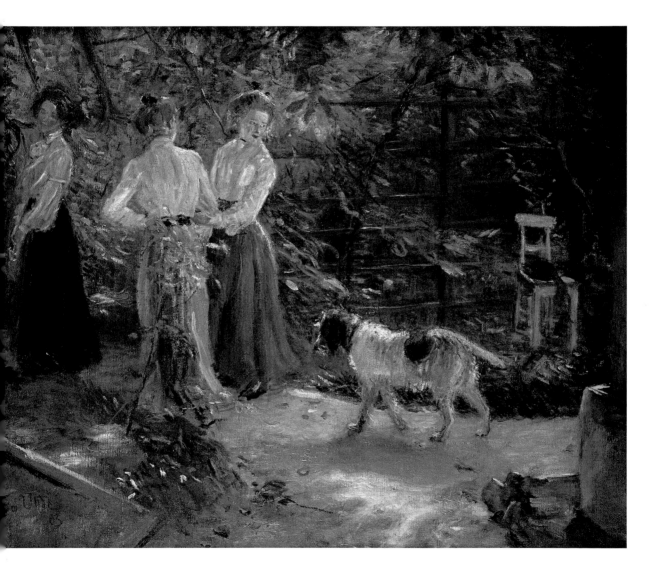

place d'anvers in paris

Oil on canvas, 102 x 136 cm
Piacenza, Galleria d'Arte Moderna Ricci Oddi

* 1841 in Venice
† 1917 in Paris

The Venetian painter Federico Zandomeneghi was, like his compatriots Giuseppe de Nittis and Medardo Rosso, drawn to Paris as if by a magic spell. He settled there in 1874, probably encouraged by the report by his friend the Italian art-critic Diego Martelli that year, in which the latter had written enthusiastically about the first Impressionist exhibition. At the fourth exhibition held by the Impressionist artists in 1879, Zandomeneghi displayed, among other works, his portrait of Diego Martelli, who had introduced him to Degas. At the latter's invitation, Zandomeneghi took part in the Impressionist exhibitions of 1879, 1880, 1881 and 1886.

Zandomeneghi had started his artistic training in Venice and Pavia. In 1862 he had got to know the "Macchiaioli" in Florence, the group of artists so called after their predilection for patches ("macchia") of colour. Zandomeneghi worked with them in the open air and familiarized himself with their technique.

Zandomeneghi fought with Garibaldi's units in the 1860s for Italian unification, the formation of an Italian national state, and against the country's occupation by Austria and France. In Paris though he devoted himself entirely to art, and was friends in particular with Renoir and Degas. His works were purchased by the Impressionists' gallery-owner and dealer Paul Durand-Ruel.

Zandomeneghi followed the example of his role-model Degas, devoting himself to the depiction of attractive young women in a variety of everyday situations: washing, combing their hair, powdering themselves or sitting in the garden or café. At the same time, like his fellow-Italian de Nittis he developed into a landscape painter of some note. The growing demand for Parisian cityscapes and motifs from the environs was what the dealers had in mind when they got "their" artists to satisfy the needs of the market.

The painting *Place d'Anvers* makes this little square look bigger than it is in reality. Topographical authenticity, as so often with the Impressionist painters, was not guaranteed. Views like this simply do not have the "objective" fidelity of photographs, even if the angle, looking directly on to the back of a figure cut off by the bottom edge of the picture, gives the impression of a snapshot.

The row of trees down the middle of what is in fact not a square but an elongated oblong creates the impression of spatial depth. In the middle of the picture children are playing in the sun, while their mother sits in the shade of the houses. Zandomeneghi has not shied away from depicting the extremely bright sunlight, in which the paving appears almost white. In the shade, the coloured components are dominant: the – in actual fact, grey – cobbles are reproduced in densely packed strokes of blue, red, yellow and white.

This unusually powerful and fresh painting shows Zandomeneghi as a typically Impressionist artist. His relationship to this style was however fragile. Ultimately Zandomeneghi developed an individual style that seems to have little in common with Impressionist principles, but rather with its use of intensive colour comes closer to the Symbolism of such as Giovanni Segantini.

"то let the friendship of all things in the open air come to the fore, in the same rhythm, with the same avidness, herein lies the brilliance."

Paul Cézanne

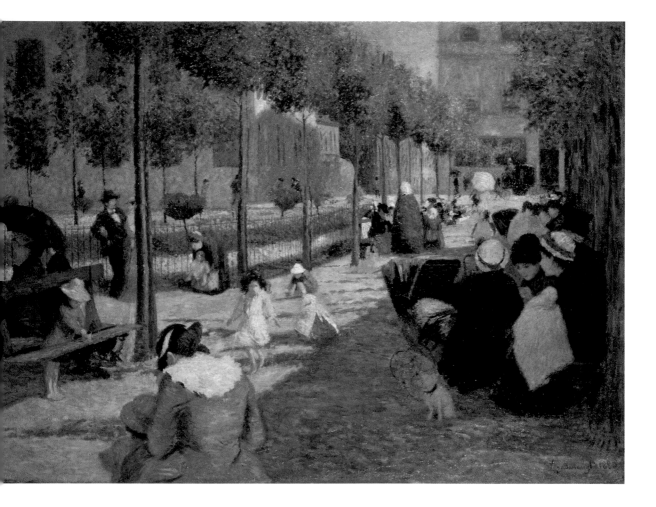

To stay informed about upcoming TASCHEN titles, please request our
magazine at www.taschen.com/magazine or write to TASCHEN America,
6671 Sunset Boulevard, Suite 1508, USA-Los Angeles, CA 90028,
contact-us@taschen.com, Fax: +1-323-463.4442. We will be happy to
send you a free copy of our magazine which is filled with information about
all of our books.

© 2007 TASCHEN GmbH
Hohenzollernring 53, D–50672 Köln
www.taschen.com

Project coordination: Ute Kieseyer, Cologne
Editing: Jürgen Schönwälder · Büro für Kunstpublikationen, Munich
Translation: Michael Scuffil, Leverkusen
Layout: text & typo · Anja Dengler, Munich
Production: Tina Ciborowius, Cologne
Design: Sense/Net, Andy Disl and Birgit Reber, Cologne

Printed in Germany
ISBN: 978-3-8228-5325-2

Page 1
CLAUDE MONET

<u>Water Lilies</u>
1906, oil on canvas, 92 x 90 cm
Worcester Art Museum, Massachusetts

Page 2
EDGAR DEGAS

<u>The Blue Dancers</u>
1890, oil on canvas, 85 x 75.5 cm
Paris, Musée d'Orsay

Page 4
PIERRE-AUGUSTE RENOIR

<u>Female Nude in the Sunlight</u>
c. 1875/76, oil on canvas, 81 x 65 cm
Paris, Musée d'Orsay